traditional penmanship

LETTERING WORKBOOKS

traditional penmanship

ANNE TRUDGILL

Watson-Guptill Publications / New York

The Diagram Group

Designer	Philip Patenall
Editor	Randal Gray
Calligrapher	Anne Trudgill
American consultant	Marian Appellof
Art staff	Lee Lawrence, Paul McCauley, Graham Rosewarne

Acknowledgements
We would like to thank the following calligraphers
for permission to produce their work:
Maura Cooper (p26, St Columba quotation); Ian
Mattingly (p78, Ecclesiastes); Peter Thornton (p78,
two examples); Villu Toots (p78, Old Estonian
sayings).

© Diagram Visual Information Ltd 1988

First published in 1989 in the United States
by Watson-Guptill Publications,
a division of Billboard Publications, Inc.,
1515 Broadway, New York, New York 10036.

Library of Congress Cataloging in Publication Data

Trudgill, Anne.
 Traditional penmanship.

 (Lettering workbooks; vol. 2)
 Bibliography: p.
 Includes index.
 1. Calligraphy. 2. Penmanship. 3. Lettering.
I. Title. II. Series
Z43.T8 1989 745.6'1 89-5472
ISBN 0-8230-5400-4 (pbk.)

Printed and bound by Snoeck Ducaju & Sons,
Ghent, Belgium

1 2 3 4 5 6 / 94 93 92 91 90 89

Lettering Workbooks

THIS BOOK IS WRITTEN TO BE USED.
It is not meant to be simply read and enjoyed. Like a course in physical exercises, or any area of study, you must carry out the tasks to gain benefit from the instruction.

1 Read the book through once.
2 Begin again, reading two pages at a time and carry out the tasks set before you go on to the next two pages.
3 Review each chapter by re-examining your previous results and carrying out the review tasks.
4 Collect all your work and store it in a safe place, having written in pencil the date when you did the work.

LEARNING HOW TO DO THE TASKS IS NOT THE OBJECT OF THE BOOK. It is to learn lettering and calligraphy by practicing the tasks. Do not rush them.

LETTERING WORKBOOKS ARE:
1 A program of clear instruction.
2 A practical account of various techniques and procedures.

Like a language course, the success of your efforts depends upon you.
YOU DO THE WORK!

Contents

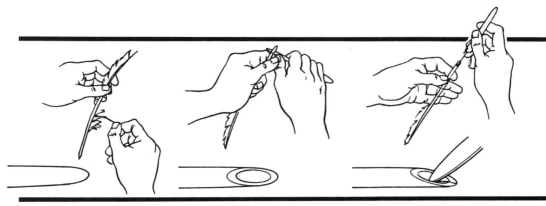

ijklmnopqr
abcdefghijklmnopq
RSTUVWXYZ
defghijkl

Topic finder

Introduction

This book is based upon the idea that calligraphy can be learnt by students understanding the structure of the letterforms and attempting to make letters themselves. This is what is needed rather than developing accurate copying skills.

Over the centuries, calligraphy has contributed much to the richness of lettering. The letterforms that were originally made by scribes endeavoring to write clearly and beautifully have developed into plastic, metal and wooden letters; type and print variations abound, and modern technology provides us with moving letters and numbers as well.

The scribe cannot compete with this progress, but, like other craftsmen, works within natural laws, and continues to write beautifully for discerning people everywhere.

If you are keen to learn calligraphy, follow the book, give yourself time and be prepared to enjoy yourself as you progress and follow the art of traditional penmanship. It aims to show you just how the letters of historical manuscripts were constructed. The tools that were used then are still used today. Tasks which accompany the alphabets enable you to begin work on each set of letters, and they can be used more than once if you wish to monitor your progress.

More powerful than all poetry, more pervasive than all science, more profound than all philosophy, are the letters of the Alphabet, twenty-six pillars of strength upon which our culture rests.

OLAF LAGERCRANTZ

Chapter 1

 Oh! nature's noblest gift – my grey goose quill:
Slave of my thoughts, obedient to my will.
Torn from thy parent bird to form a pen.
That mighty instrument of little men! **"**

BYRON

Task
Workspace
Make a small workspace where
you, your desk and a container for
your tools can fit.
● The light source should be even
and fall from the front or the
opposite side to your writing
hand.
● The work surface should be at a
slope but the tools will need to be
stored on a flat surface.
● A small wall area on which you
can display your work or the work
of other people to give you
inspiration and confidence.

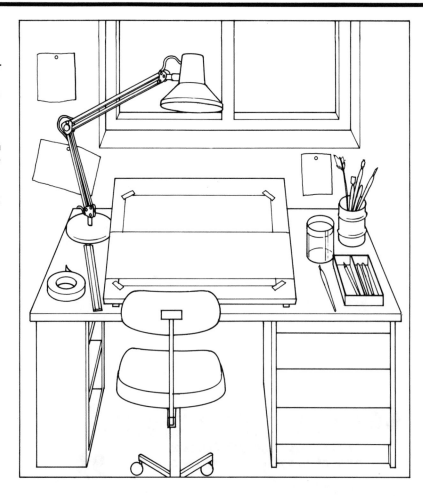

TOOLS AND MATERIALS

Traditional letterforms are the result of using traditional tools. The marks are made by hand-held implements and not by machines. Later, typographical designers faced with producing new alphabet forms returned to these original shapes and incorporated them in their designs. This chapter introduces you to the tools which have been used for over 5000 years. You can construct your own tools from both natural and synthetic materials, or you can use readily available tools to make traditional marks similar to those made by scribes of earlier times.

Prepare a drawing board
1 If you do not have a drawing board, you can make one. Find a strong, flat board with straight edges. Prop it up at an angle of 45° using bricks or books. Make sure it is firm.
2 Tape three sheets of good thick paper securely to the board to create a firm but "sympathetic" writing surface.
3 Use a sheet of ruled lines as a guide underneath the sheet of paper you're writing on.
4 Write onto a sheet of layout paper which is not taped down. This paper needs to be free to move upwards as you write down the page so that your hand stays at the same level on the board at all times.
5 Use a sheet of layout paper to protect your work from grease and splatters, etc.

Posture
Body weight should go through the spine. Legs and both feet should rest squarely on the floor. Avoid weight going forward into the arms. This position should give you:
● Steady ink flow
● Good view of your work
● Relaxed working posture which will not tire you

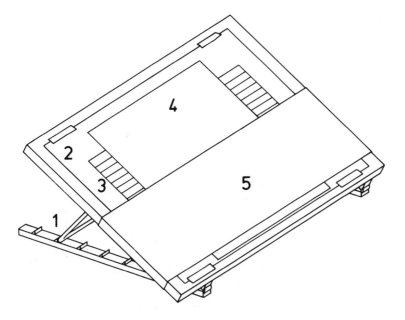

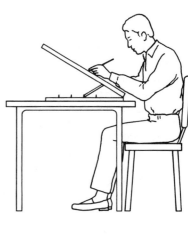

A brief history of writing

The development of knowledge and the spread of ideas has relied upon the use of the written word – which, in turn, relies upon the use of convenient symbols and letterforms. Early man, drawing pictures on clay tablets with a stick, was limited in what he could record. So limited that developments such as reed pens and papyrus writing material represented a giant leap forward – just as great a leap as pen and paper would later be.

As new tools arrived, they were not just more convenient; they also changed the marks that were made. Sometimes the changes made writing quicker, sometimes they permitted elaboration. Sometimes they allowed more writing to be crammed on a page and sometimes they encouraged the writer to turn his script into an expressive art form. The essential elements of writing are what the tool will permit and what the hand can achieve.

In a book like this it is not possible to present a detailed history of writing; we can only briefly introduce a fascinating subject. Sadly, we cannot ever discover more than a small fraction of the history of our writing. While man has used marks and signs for tens of thousands of years, we can only trace our historical scripts back for about 3000 years.

At that time, the Phoenicians were the great trading nation of the Mediterranean. Successful trading requires good written records and the Phoenicians used a script based on 22 letters, some of which we would recognize today. This alphabet was taken up by the Greeks who made some modifications. The Romans adopted it and, through conquest, spread it across the western world.

Any European looking at a Roman inscription will recognize the symbols even though he may not understand the words. There was nothing inevitable about this; the symbols have survived because they are convenient to use. Roman numerals, on the other hand, were difficult to read, almost impossible to do arithmetic upon, and have consequently been replaced by Arabic numerals. This is typical of how writing has developed – it has been a process of selection and refinement and it has not ended. Indeed, today's technology may actually be speeding up the development process once again.

Early Roman letters

Examine a Roman inscription carved out of stone and you will see capital letters only. Big, graceful

Earliest alphabet

Phoenician letters from the Moabite or Mesha Stone, dated to 842 BC. The writing ran from right to left.

Chiselled capitals

Letters from a Greek inscription in white marble, 4th century BC.

Roman monumental

Roman capitals on the tombstone of Gaius Valerius Victor (from Lyons), standardbearer of Legion II Augusta at Isca (Caerleon), South Wales, after AD 74.

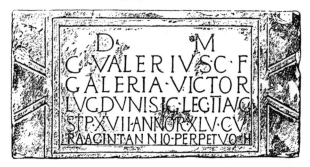

and square, they were well suited for use on inscriptions. However, they would not have been an ideal written hand because they were slow and exacting.

Rustica

The Romans therefore needed another writing style for everyday use. This had to serve for letters written on papyrus using a square-ended reed pen. It was a compressed style because writing materials were expensive, but it was a flowing style because it needed to be written quickly. The success of Rustica is evident in that it survived to the end of the Western Roman Empire. Even after that, it persisted as a decorative hand for the opening letters of chapters or paragraph.

Uncials

Improvements in writing implements eventually led to the adoption of Uncials as the favored script of Western Europe. Its rounded letters were quicker to write than Rustica; a factor of increasing significance in the first millennium after Christ. The spread of Christianity led to an ever growing demand for bibles and religious texts which were copied by monastic scribes. Because this was their main purpose in life, the scribes were encouraged to use the rounded style to produce beautiful flowing writing worthy of its message.

Half-Uncials

Half-Uncials were a further development. Again, it seems likely that their adoption was due to the need for increased speed in producing texts. Within this hand there began to emerge the ascenders and descenders that we now associate with lower case letters. It was the forerunner of all of today's minuscule letters.

Carolingian

As Western Europe broke up into new Romano-Christian influenced but nevertheless barbarian kingdoms, consistency in scripts across Europe was lost. Local regions developed their own hands and, although many were clearly derived from Uncials and Half-Uncials, there were considerable variations. Shortly before AD 800 there arose a new European leader in Charlemagne who, although he could not read, was shrewd enough to recognize the power of the written word. His was the initiative to re-establish standard letterforms.

 Named after him, the Carolingian form was the first true minuscule hand. It was elegant with long clubbed ascenders and descenders that needed four guidelines for each line of writing rather than the two needed by capital hands. It established

Roman hands
Roman and Rustica capitals from a graffiti painted on a Pompeii wall before AD 79.

Church writing
Uncial script from ecclesiastical regulations in Latin, 6th or 7th century.

Celtic flair
Half-Uncials from the Gospels in the Insular style, almost certainly Irish, 8th century.

Carolingian Renaissance
Very early Carolingian form from a Salzburg manuscript of Alcuin's letters, written 798–99. Alcuin of York, 311 of whose letters in Latin survive, was the powerhouse of the Carolingian Renaissance.

A brief history of writing

itself as the formal bookhand in Europe and survived in that role for nearly 300 years. It was one of the most significant developments in the history of writing and its influence on today's printed material is still apparent.

Gothic

In the Middle Ages there were increased demands for documents with secular purposes. They led to a severe shortage of vellum and to a consequent sharp increase in its price. There emerged the need for a hand which was as quick to write as the Carolingian, but which was sufficiently dense to make economical use of the available vellum. The answer to the problem was Gothic, a neat compressed style which sacrificed roundness and cut short ascenders and descenders in order to get as much text as possible onto a page.

Gothic variations

Though the term Gothic derives from the name of the Old German people, the hand was widely used across Northern Europe. However, it was not a single style, rather a whole family of hands. The variations tended to develop regionally but the essence of the style is so strong that the family relationship is always clear.

Rotunda

Though most of Europe adopted a standard Gothic form with heavy angularity, Italy showed a marked resistance. There, a compromise style was adopted between Gothic and other earlier forms. It is known as Rotunda and, while its Gothic influence is apparent, so too are the rounded letters from which its name derives.

Italic

The Renaissance began in Italy and had a profound effect upon the calligraphic hands. Gothic was swept away and back came the stylish influences of Carolingian. Now, however, they were more pronounced, with long and flowing ascenders and descenders. The script bloomed into Italic, a family of hands that re-established elegance. The style emerged in the 15th century just as the first printing presses were appearing and was promptly adopted for use in typography. It has remained for over 500 years as part of a popular repertoire of type.

Copperplate

While Italic remained as part of the typographer's stock in trade, hand scripts moved on. The arrival of the quill pen allowed scribes to mimic what had once been a style of copper engravers. While

Northern Gothic
Gothic Textura from the Kinloss or Boswell Psalter, Cistercian Abbey of Kinloss, Scotland c1500.

Southern Gothic
Gothic Rotunda from a Florentine liturgical text, written c1500.

Venetian Italic
Italic from the regulations to be kept by the Procurators of the Basilica of St Mark, Venice, written by the priest John, 1558.

Eighteenth century Copperplate
Copperplate by Joseph Champion from George Bickham's *The Universal Penman* 1743.

similar to Italic in its elegance, Copperplate has a fine gradation in line thickness which encourages style and ornamentation. The engravers achieved this with a fine cutting tool, the calligrapher thanks to the quill's flexibility. Copperplate or Roundhand soon became the accepted hand and lasted into the 20th century. However, before that, the quill had long been replaced by metal pens that were mass produced for the schools attended by many of our parents and grandparents.

Foundational hand

Toward the end of the 19th century William Morris (1834–1896), whose interest lay in medieval designs, created the Arts and Crafts Movement in England as a reaction to mass-produced products. Morris had a direct influence upon Edward Johnston (1872–1944) who, having studied old manuscripts at the British Museum, became fascinated by the tools and techniques used to provide them. He rediscovered the old skills used in creating various letterforms and went on to teach them to a new generation of calligraphers. To facilitate his teaching, Johnston developed his own calligraphic hand. This he called the Foundational hand. He based it on the Carolingian letterforms in the 10th century Anglo-Saxon Ramsay Psalter.

Foundational hand
A basic teaching hand, the ideal alphabet to start calligraphy.

Modern revival
Black letter or Gothic pen hand by Rudolf Koch pre-1934.

Modern developments

In 1906 Johnston published what has become the basic reference manual for calligraphers today – *Writing, Illuminating and Lettering.* It is full of practical advice on how to make letterforms and how to design books and manuscripts.

Johnston was not the only one to be interested in the traditional letterforms. In Germany, Rudolf Koch (1876–1934) was familiarizing himself with old manuscripts and, because of his Germanic roots, he concentrated on developing the Gothic form. Like Johnston, Koch drew to him a new generation of calligraphers.

Some members of this new generation, in both England and Germany, had a wider interest in lettering. They designed new hands; for instance, Alfred Fairbank developed the chancery Italic hand into a simple model for Italic handwriting. Others were more active in designing new typefaces. The 1920s saw a blossoming of many that we treat as standard today: Gill Sans, Futura and Optima, for example. Often they are clear and without serifs – a design development which divorces type from its roots in calligraphy.

In England we still see the London Transport letters that Johnston himself designed in 1916. His student Eric Gill (1882–1940) became one of the best-known typeface designers and letter cutters in the country, while in Germany, Koch's students Imre Reiner and Hermann Zapf produced new alphabets in rich profusion.

Today, printing is moving on, revolutionized by the use of computers. Once again there is a reaction to mechanically-produced letters, and a great number of people have reacted by simply taking up the broad-edged pen and beginning to learn the art of traditional penmanship.

©DIAGRAM

15

Using pens

Brushes and pens are both traditional tools which have been used by scribes for over 5000 years. Dipping into a liquid and writing with it is a rhythmic writing technique, which we still use today. We call the fluid "ink", but it can easily be diluted paint. The pen needs to be kept clean so that the ink flows freely down the nib slit to the writing edge. Reservoirs help to hold the ink so that the dipping procedure is regulated. Some reservoirs can be slipped onto the nib and lie underneath like a shallow cup, while others sit perched on top of the nib. Either way they tend to hold the sides of the nib and make it a less flexible tool. Metal reservoirs and nibs have to be degreased before use, otherwise the ink will run off the nib and retract from it. Sucking them, boiling them in water or running them through a lighted match are all possible methods of doing this.

Nib widths

Nibs are available in an enormous range of widths. The wider the nib, the greater the contrast between the thick and thin strokes produced. Two manufacturers' nib sizes are shown here.

William Mitchell roundhand nibs	**Brause** nibs
0	5
1	4
1½	3
2	2½
2½	2
3	1½
3½	1
4	¾
5	½
6	

Ink reservoirs

Having to dip the nib frequently into the ink can often slow down the rhythm and the flow of the line of text. Modern nibs are often supplied with a reservoir, a container which holds a pool of ink on the nib. These are either detachable clip-on reservoirs which go above or below the nib or form an integral part of the nib itself.

1 Clip-on reservoir. This slips underneath the nib and forms a shallow cup which just touches the underside of the nib points. It should not force the slit open as this is likely to cause flooding when in use. This type of reservoir can be removed for cleaning.

2 The clip-over. This is attached to the top side of the nib on the shoulders of the nib away from the writing edge. This type can also be removed easily for cleaning.

3 Automatic lettering pens have a diamond-shaped gap inside the nib, between the two blades. One edge of the nib has tiny grooves cut into it. This edge is held uppermost when writing and the grooves help the ink flow.

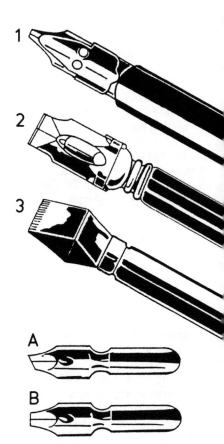

Pen and brush care

When pens are not in use, do not store in airtight boxes. Leave them in a jar or pot, in the air, so they don't rust.
● Rusty nibs and nibs which split open when you write should be thrown away.
● Scratchy nibs can be sharpened on fine emery paper.

● Left-handed scribes might like to steepen the oblique angle of their steel nibs using a stone if one is available, or emery paper if not.
● Brushes should be reshaped when washed and when quite dry they can wear a cardboard collar to protect the hair.

Left-handed calligraphers

If you are left-handed you may find left oblique nibs (**A**) easier to use than square cut ones (**B**). You have to decide what is best for you. Several first class calligraphers are left handed so it is no excuse for not succeeding!

Pen angles

1 This is the general handwriting position. There is a "controlled leak" ink supply from a roller ball or a fountain pen which works well with a flat writing surface. Ink from a dip pen, however, would run down the nib too quickly and blobbing would result.

2 For display work and large letters a gentle slope is best. You don't want the paint or ink to run down the letter and collect at the bottom of it.

3 Traditionally, a writing desk was always sloped and until recently even school desks were too! This position is for general calligraphy. Notice the steep angle of the pen to the paper. The pen rests on the knuckle of the forefinger, NOT in the soft flesh between thumb and forefinger. This is a common error.

4 For fine calligraphy you need to sit as upright as possible and keep your weight OFF your writing arm. Don't be tempted to lean forward when writing small. You will get tired and stiff with too much concentration! Body weight should be held in the spine, and the feet flat on the floor help to support your frame. This body posture leaves your arm free to move easily with the pen.

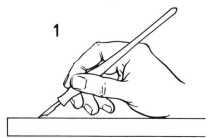

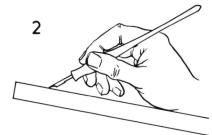

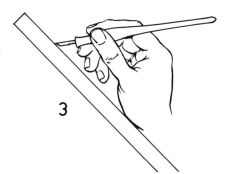

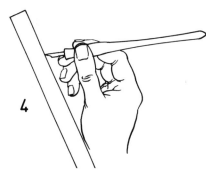

Task
Working positions

It is essential that you experiment with these basic positions before you learn to write. Practicing hard will mean you concentrate and that will lead to tension in the body and in your writing. Simply use a felt pen and layout paper to acquaint yourself with pen strokes. Be aware of your board angle, pen angle, seat height, hand position, etc. Make any adjustment necessary *before* you learn the alphabets.

For Copperplate writing

When using a *flexible pen* left-handers have the advantage for once! Right-handers may well prefer to use the elbow-joint nib (page 19) to help with the extreme angle of the letters. Turning the paper can help also.

Hints for left-handed calligraphers

● Left oblique nibs can be purchased. If required, the angle of the nib can be increased by rubbing with FINE silicon carbide paper.

● Tilt the paper or steepen the angle of the drawing board to make yourself more comfortable.

● Keep work to the left hand side of your board. Turn your head a little to the left and don't write across your body – only as far as your chin. Keep your elbow tucked into your waist.

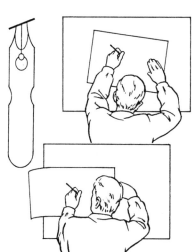

Task
Preparing nibs

New nibs need to be cleaned before use, otherwise the ink will not flow freely. Remove the manufacturer's lacquer from both nibs and reservoirs, either by boiling them in water or by putting them into the flame of a lighted match and then wiping clean.

© DIAGRAM

Choosing pens

These two pages illustrate a variety of writing implements available. The ones marked with an asterisk (*) are the ones you need to start with.

Since it's the size of the nib that dictates the size of your letters, try to assemble a variety of nib sizes. Don't be tempted to write small if you are a beginner. The shapes of your letters will be easier to criticize if you make them at least ½in (1cm) high. Pens are very personal so don't allow others to borrow them!

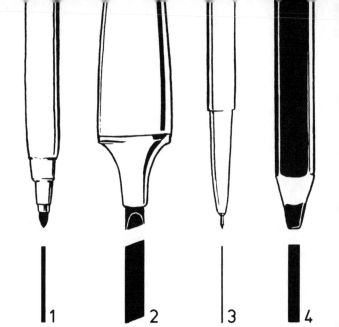

1 Instant marker pen.
2 Chisel-ended felt tip pen*.
1 and 2 are ideal for practicing and planning layouts. They are available in a variety of widths and colors.
3 A fine tip pen is useful for ruling-up templates.
4 A carpenter's pencil for practice and experimenting with different layouts.
5 The double pencil is the most useful dry pen of all. Simply bind two pencils together at the top and bottom with tape or rubber bands to produce an outline pen which shows

clearly the letter construction. To make a broader pen, place an eraser between the two pencils and then bind them together. If you want a narrower pen, shave off some of the wood from the pencils along their lengths before binding*.
6 Chisel-ended felt tip pen which has had small wedges cut out of the tip with a scalpel, producing a decorative mark.
7 Reed pen. These can be made from bamboo, honeysuckle and other tubular stems. The reed pen is the original broad-nibbed pen and is ideal

for large letters. (See instructions for pen-cutting on pages 20-21.)
8 A synthetic "reed" pen. Nylon tubing from a hardware store can be made into a synthetic "reed" pen. The nib can be cut into to make a pen which produces a double line.
9 A quill. This is made from a cured flight feather of a goose or swan. It is cut in the same way as a reed pen. Pens 7, 8 and 9 can be used with reservoirs added (see page 23).
10 Homemade poster pen. Made by covering a piece of balsa wood with felt and gripping them together in a

Task
Collecting pens
Start collecting and making pens. Store the pens with the nib pointing upward, not flat in a box. A jar is ideal for this. Having several pen holders will avoid the need to change nibs too often – this can damage them.

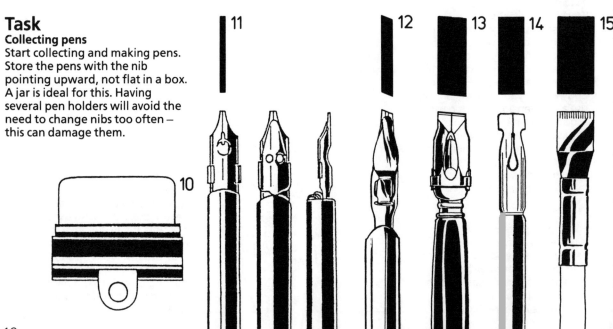

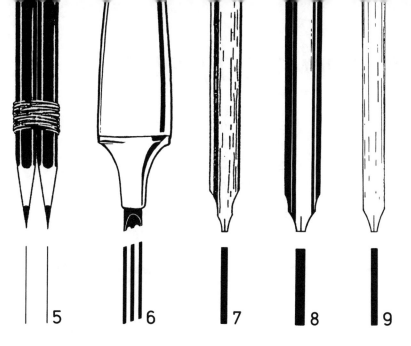

5 6 7 8 9

Task
Making mountains
Rule out some writing lines 1¼in (30mm) apart on A3 paper. With the double pencil pen (no.5) make mountains with a 45° angle. Keep the angle constant. Repeat, but use a 30° angle instead. These exercises are helpful even before you start writing.

bulldog clip. This produces an inexpensive pen with a broad nib which is useful for display work and experimenting with design.

11 William Mitchell Roundhand nib with a slip-on reservoir (top, bottom and side views).

12 Brause nib with its reservoir on top of the nib. Both 11 and 12 are available in a range of widths.

* You will need either 11 or 12.

13 Poster pens also have their reservoirs on top of the nib and a right oblique writing edge. This pen is ideal for display work.

14 The Witch pen has a writing edge which copes with textured papers very well.

15 Boxall Automatic pen. This range includes a variety of nib widths.

16 Boxall Automatic pen with a decorative nib.

17 Scroll nibs are available in sets consisting of a variety of widths, all giving a double line.

18 The Decro Script pen is useful for practicing skeleton letters in various sizes and weights.

19 Coit pens are expensive but have a variety of writing edges which

produce decorative marks, and are ideal for display work.

20 Fountain pen. Using a fountain pen with an Italic nib for your everyday writing will help to improve it*.

21 A shadow fountain pen nib gives two lines. This is ideal for analyzing your strokes as well as being decorative.

22 Regular shaped nib for Copperplate and Roundhand scripts.

23 Elbow joint nib used exclusively for Copperplate writing.

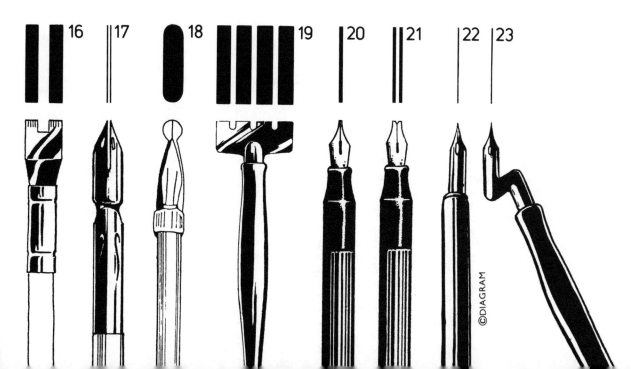

16 17 18 19 20 21 22 23

©DIAGRAM

Making quills and reed pens

The reed pen was the earliest broad-edged pen. It was replaced by the quill which was exclusively used in the West for many centuries before the steel nib was invented in the early nineteenth century. The very word "pen" comes from the Latin *penna* (feather), a recognition of the quill's long dominance.

Flexible springy writing tools can be made from reeds, feathers or lengths of nylon tubing. The tool is made by cutting away at the hollow barrel and making a slit to allow the ink to flow. The result is a lightweight pen where the maker can easily adjust both the length of the pen and the width of the writing edge.

For pen cutting you will, of course, need a pen knife. Its blade should be hollow-ground and sharpened to cut precisely. Choose one with a good handle so that you can exert some pressure (this will be necessary when cutting bamboo).

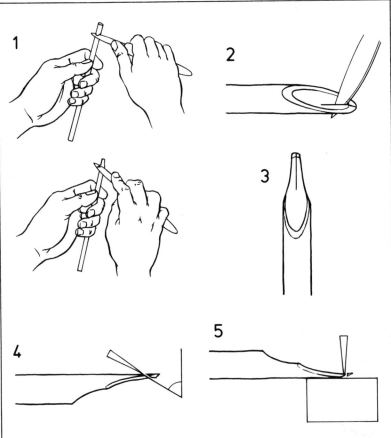

1

2

3

4

5

Cutting a reed pen
A reed pen is traditionally cut from the tall reed *Phragmites communis* that occurs in freshwater margins from the Arctic to the tropics (not readily available in Britain), but any other hollow stem can be used. Two alternatives are honeysuckle and bamboo (not strictly a reed pen).
Instructions
1 Cut a length of reed 6¼in (160mm) long, and cut one end off at an angle of 45°.

2 Make a slit opposite the cut about ⅕in (5mm) long.
3 Shape the pen either side of the slit, making the two "shoulders" even.
4 Slice into the tip with the knife at an angle of 60°.
5 Rest the pen on a smooth, flat surface and cut across the end of the nib. Do this with the knife held at 90° to the slit. Use a square cut for right-handed scribes and an oblique cut for left-handers.

Instructions for curing a feather
The process of hardening by heating will make the quill strong and durable.
1 Remove the wide barb and cut off the end of the barrel. Soak the feather in water overnight.
2 Remove feather from the water and hook out the membrane from inside the barrel using a blunt instrument.
3 Heat some silver sand (the type used in potter's kilns) in a deep frying pan. Maintain a low temperature throughout the process. Using an old spoon, gently fill the barrel of the quill with the hot sand. Plunge the quill into the sand for 2–3 seconds. Take care not to overheat the quill by pushing so far into the pan that it nears the bottom. Remove.
4 Check the quill:
• if it has blistered, the sand was too hot
• if it has not turned clear, the sand may not have been hot enough. Try again.
• if it has become clear without blistering, then it is fine. The slit should run clean and straight when the knife is used.
5 Shake the sand out of the quill and wipe it with a coarse cloth to remove the outer membrane. This resembles a thin plastic "skin" on the outside of the barrel. The barrel should now be clean and shiny.
When you have had practice, you will be able to do several quills at once. Use ordinary feathers to practice with.

Choosing a feather

The best feathers to use are the first flight feathers of swans and geese. These birds moult each summer, so you may be lucky enough to find the feathers you need. Flight feathers have one narrow and one wide barb. On other feathers the two sides are more evenly matched. Place the feather in your hand as if to write with it. It should curve over your hand (see *below*). If you are right-handed, you will need a feather from the left wing, and vice versa.

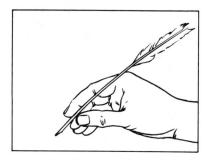

Cutting a quill pen

1 Remove the barb from the lower end of the feather.

2 Hold the feather with the tip of the barrel pointing away from your body. Using a sharp knife, cut off the tip of the barrel at an angle of 45°. (When using a sharp knife, always take care to cut away from yourself.)

3 Cut a slit in the center of the barrel. Stop cutting when the crack appears. If the feather has been properly tempered, the crack should run straight.

4 Turn the pen over and cut away a piece from the side opposite the slit. This piece will be roughly half of the circumference of the barrel.

5 Shape the "shoulders" of the pen on either side of the slit.

6 Gently scrape away at the underside of the nib to make the surface flat and smooth.

7 Place the pen on a flat, hard surface with the underside of the nib downward and the nib pointing away from yourself. Move the blade forward at a shallow angle to cut a small piece from the tip.

8 Keep the quill in the same position as in (**7**) and cut vertically downwards to neaten the end of the nib.

1
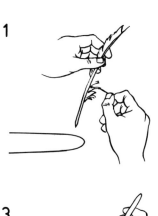

2
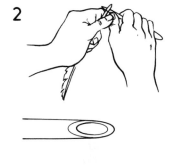

3
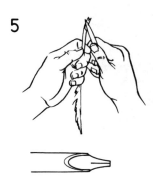

4
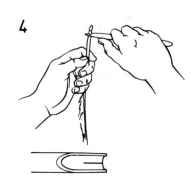

5
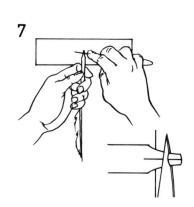

6
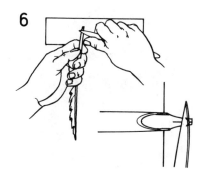

7
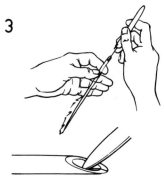

8
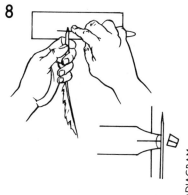

© DIAGRAM

Inks and paints

There are basically two types of commercially produced inks: those solvent in water, which can be diluted to produce thinner body and color; and waterproof inks, which have a gum base and which cannot be diluted successfully.

Soluble inks flow more freely, do not clog the pen and can be washed away easily but may produce lines of varying intensity depending on the amount of ink released from the nib and absorbed into the surface.

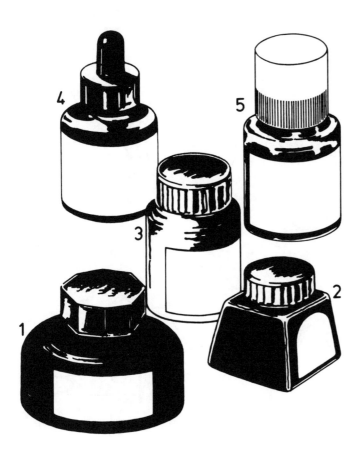

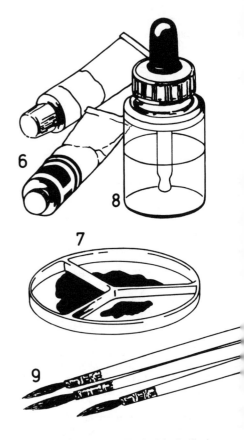

Inks
Experiment with different combinations of ink, and paper to find out what suits you best. When choosing ink always make sure it is *non*-waterproof. Waterproof inks contain gum which will clog your pen.
1 Ordinary permanent black fountain pen ink is the best ink to practice with.
2 Black indian ink is good for finished work as it is dense and very black.
3, 4, and **5** There are many other inks on the market, experiment with different colors. Secure ink bottles to the table to avoid spillage.

Paint
6 Gouache. Some gouache paints (designer colors) will add a new dimension to your work. The following colors would be useful to have: Zinc (Chinese) white, cobalt blue, lemon yellow, emerald oxide of chromium (mix in lemon yellow to give it body), spectrum red or vermilion hue.
7 A mixing dish for preparing paint. If you already have watercolors you can use them and add zinc white to give opacity to your letters when it is appropriate to have bold opaque color.

8 A dropper bottle filled with distilled water is ideal for mixing paint. Always add the water to the paint *drop by drop*. If you are using paint for a long piece of work, add drops of water occasionally to compensate for evaporation.
9 Use cheap brushes for mixing paint and for transferring paint from the mixing dish to the nib. Shorten the handles on them to prevent accidents.

Stick color

It is possible to buy modern stick inks and paint in good art supply shops; they are available in several colors, although the traditional colors are black and red. The stick is ground by being held upright and rubbing it into a pool of water on a special palette; this requires patience, if you want to obtain a good consistency.

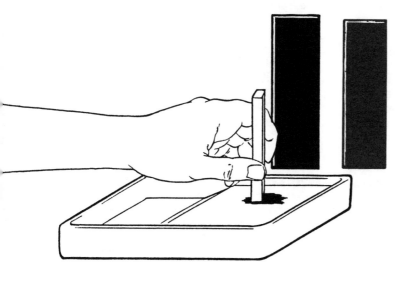

Quantum

Don't separate out paints from ink. They both make useful writing fluids and work well together on the page. Traditionally black Gothic minuscules work well with vermilion capitals. Red, blue and green majuscules make effective headings for black manuscripts. Don't be afraid to use well diluted paint to write your text. Store the paints safely, they can be reconstituted whenever you wish, you just need a milky consistency.
1 Pen strokes using vermilion paint.
2 Brush strokes using vermilion paint.
3 Pen strokes using black stick ink.

Task
Patterns
Acquaint yourself with your new pens by experimenting with ink and paint. Notice how often you have to dip into your ink, and develop a rhythm. Don't attempt letters, rather make patterns.

Task
Mixing paint
The paint will never flow if it is too thick. Make a milky consistency and concentrate on allowing the fluid to flow from the nib. Dilute paint to a gentle line and work with a small nib. Store color in airtight jars. If it is too thin, simply leave the top off and allow it to evaporate a little!

Task
Make your own ink reservoir
If you make a reed pen (pages 20-21) you may decide to make a reservoir to go with it. Cut a thin strip of aluminum from a soft drink can. It can be curled by rubbing hard on one side.

Loading the pen
Calligraphy pens are best *not* dipped into writing fluid, *not* even ink, as this creates uneven ink distribution. A controlled ink flow is best provided by wiping the pen and reservoir with an ink/paint laden brush. With this method there need be no blobbing onto the page. Work with the fluid and brush on your non-writing side and bring the brush to your pen. It is not an easy process to start with, but after practice it is far superior to relying on a "dip and shake-off method"!

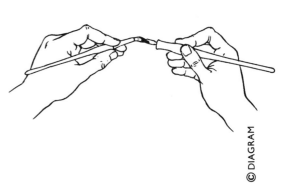

Papers and parchment

The traditional surfaces for fine writing in books and manuscripts are *parchments*. These are specially prepared animal skins, the finest of which is *vellum*; this is usually calfskin. Other parchments are made from goatskin and stripped sheepskin.

The belly of the animal has the softest skin so this is used to make parchment; white thicker areas provide material for the bookbinder. The special preparation that turns an animal skin into a parchment is lengthy and messy, but is still carried out by craftsmen today. The processes include soaking skins in lime, scraping, drying and stretching them. After the best parchments are selected for writing upon, the scribe still needs to add a few finishing touches. Pumice is used to remove grease from the surface and to raise the nap for the pen strokes. The surface needs to have tooth to it, but must not be absorbent and allow ink to bleed into the fibres. Lines for writing on are drawn with a hard, sharp pencil. By pricking through to the next page, the sets of lines on the following pages can be made to match the first one.

The word *paper* derives from *papyrus* which was the ancient Egyptian word for writing material they made from the water plant. By cutting the stem into narrow strips, placing them in layers, beating and compressing them, then drying them in the sun, a flexible writing material was manufactured for over 3500 years.

Since then techniques have been developed to turn other vegetable matter such as linen, cotton, hemp and wood pulp into paper.

Art shops stock a bewildering variety of paper, most of which is unsuited to the needs of the scribe. Work with a more restricted choice, but select the paper carefully for the effect you want to achieve. Here are some ideas to choose from:

Layout paper
This comes in pads of various sizes. It is smooth and translucent, so you can use guidelines under your writing page. Ideal for practice and pasting up.

Textures
Generally speaking, calligraphers require a smooth textured surface for their work. Sometimes, however, interesting effects can be used by using a highly textured surface and a large pen. Witch pens with their particular writing edge do not snag on uneven surfaces and are therefore particularly useful. A spontaneous effect is achieved by simply ignoring the fact that occasionally the ink fails to mark the paper. Small pens, however, are more likely to snag on such a surface and are not recommended.

Cartridge or drawing paper
This comes in various sizes, in pads or in sheets. Good quality, heavyweight cartridge paper is suitable for finished work.

Kraft paper
Otherwise known as brown wrapping paper, it has lines within it, ideal for writing on. Use the matt side only.

Handmade papers
Experiment with these, they vary enormously. You need flat-pressed paper with a smooth finish. Rule up carefully. Don't presume any corners are square.

Selection and storage
Look for Fabriano papers for texture, Ingres paper for subtle colors, and textured papers for special effects. Avoid coated surfaces, ideal for print but problematic for writing on. Keep a record of the papers you buy so successful ones can easily be re-ordered. Store flat between strong card covers and keep dry.

Vellum offcuts

It is not recommended that you begin work on parchment or vellum without referring to *The Calligrapher's Handbook*, edited by Heather Child (London 1985). It is however possible to experiment with these fine writing surfaces by acquiring offcuts. Even these odd end pieces need preparing by the scribe before writing can begin:

1 Rub pumice powder into the surface to raise the nap using a small block of wood covered with the finest grade of wet and dry abrasive paper.

2 Brush away the resulting dust and rule up using a very hard pencil.

3 Dab a resin powder onto the surface to prevent the ink from spreading in the fibers and brush away any excess. Resin is best used in a dolly bag and applied sparingly.

For parchment, vellum, pumice and resin you will need a calligraphy supplies shop. Paper shops can often put you in touch with suppliers who will mail goods to you direct.

Drawing equipment

The drawing equipment shown here helps you to prepare the writing surface for your calligraphy. Traditionally, pages of a book matched each other because the scribe used a stylus to prick through the position of his writing lines onto subsequent pages. These lines were scored with the stylus before pencils were invented. To avoid ink seeping into the score marks the writing was done between the guidelines. The other side of a ruled up page would therefore have a raised line; thus the two sides of a page were ruled up at once. You can best use a very hard pencil (4H) for your writing lines, a compass point for pricking through and walk your dividers down the page (see *below*) for ruling up in the traditional way.

1 T square
2 Triangles (set squares)
3 French curves
4 Flexible razor blade (for erasing on parchment)
5 Protractor
6 Ruler
7 Dividers
8 Compass
9 Pen knife
10 4H pencil

offcuts

Task

Finding drawing equipment
Some of these tools might be around the house, left over from your schooldays! If not, they are readily available from stationery stores and art shops. They facilitate *accurate* drawings on your writing surface prior to pen work. Use a hard (4H) pencil and do not erase your writing lines, or the ink will smudge.

Review

Do not underestimate the importance of using well-prepared, clean and sharp pens. You will learn from experience that a rusty nib does not allow the ink to flow well; that too much pressure on a nib forces it to open when it should not; and that you must remember to prepare each new nib and reservoir before using it. Much of this is common sense, but better results can be obtained by treating your tools with respect.

Papers and paints also need care, but most of all you have to experiment with them. If you buy single sheets of paper, this need not be too expensive. Paint will only be wasted if you dilute it too much in vast quantities. Dried paint can always be reconstituted. Experimenting with your tools to familiarize yourself with them will be well worthwhile as the more confident you become, the more proficient your work will be.

MY hand IS tired FROM WRITING,

MY SHARP PEN IS NOT STEADY;

The pen, a slender beak, spouts a dark stream of blue ink, an unceasing stream of wisdom pours from my brown, shapely hand; it spills its flow of ink from the blue-skinned holly over the page. I send my wet little pen over a whole fair of lovely books without ceasing, for the wealth of great ones, and so

MY hand IS tired FROM WRITING,

ST. COLUMBA

Home truths
Certain quotations will always attract calligraphic responses. Scribes over the centuries have felt the weariness described here by St Columba. This version is by the present day American scribe Maura Cooper who has chosen Uncials in two sizes.

Task
Pen play
Using a felt marker pen, play with the pen, making swirls, zigzags, and horizontal and vertical strokes. Remember to move the paper as you fill it up so that you are always writing directly in front of you.

Task
Doodling
Fill a whole page with doodles using pen and ink. Experiment with pulling strokes and try to get used to the wetness of the ink.

Task
Visit museums
There are many valuable old manuscripts in museums from which you can obtain a great deal of inspiration. They will intrigue you and a visit will help you understand the development of writing a little more. Buy postcards of the ones you like best.

Task
Read on
Get to know this workbook. Read through the book and acquaint yourself with the task program and the jargon. Decide how you will use the book to maximize the learning process.

1 u m e

2 DUBLIN

3 Köln

4 MOSCOW Algiers

5 Stavanger

6 AVIGNON

7 Hong Kong Melbourne

8 London New York

Examples of pen marks (all actual size)
1 Double pencil, shaved lengthwise to decrease the "width" of the "nib".
2 Felt pen
3 Automatic No. 9 pen
4 Monoline pen
5 Automatic No. 3 pen
6 Reed pen
7 Swan quill
8 William Mitchell No. 2 pen

©DIAGRAM

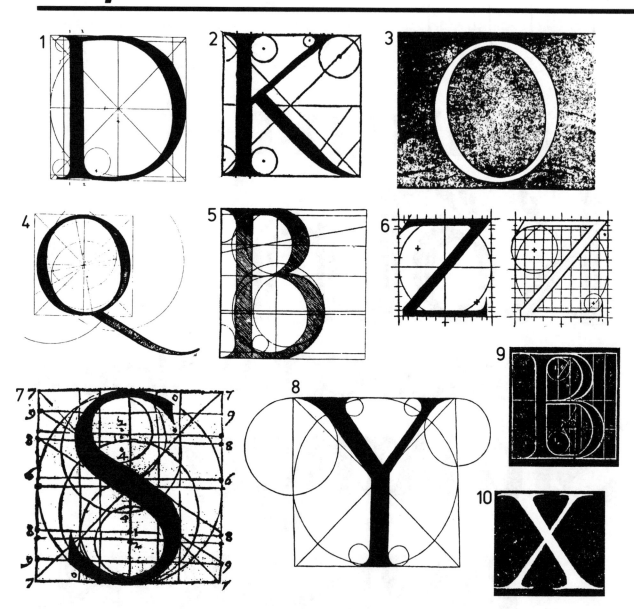

Renaissance letters
Constructed Classical Roman capitals designed geometrically in the 16th century by various European writing masters and typographers:
1 Marco Antonio Rossi (Rome printer flourished 1598–1640) from *Giardino de scrittori* (1598).
2 Juan de Yciar (1522– post 1555) from his *Arte Subtilissima* (Saragossa, Spain 1548).
3 Gianfrancesco Cresci of Milan (Vatican scribe 1556–72) from his second alphabet 1570.

4 Luca Horfei da Fano, student of Cresci and author of 1589 writing manual.
5 Johann Neudörffer (1497–1563), greatest North European writing master, published two writing manuals at Nuremburg; the B is from a c1540 alphabet.
6 Geoffroy Tory (c1480–c1533), French typographer and royal printer, from his 1529 alphabet.
7 Giovanni Battista Verini of Florence from his 1526 *Luminario* alphabet.

8 Fra Luca de Pacioli (c1450–c1520), Franciscan mathematician patronized by Duke Federigo of Urbino, from his 1509 alphabet.
9 Francesco Torniello from his 1517 alphabet published at Milan.
10 Ludovico degli Arrighi (d1528), Vatican scribe, from his second writing manual (1523).

LETTERFORMS

The various alphabets in this chapter were all developed from the Roman majuscule ("upper case or capital") alphabet. Roman, Rustica, Carolingian, Uncial and Half-Uncial only have one form, either majuscule or minuscule. The other letterforms in this chapter have both majuscule and minuscule forms. Minuscules ("lower case" or "little" letters) were developed from majuscules in order to speed up the process of writing. As the letterforms evolved they generally became easier to write quickly, but the Roman numerals were cumbersome to write and so Arabic numerals were adopted instead.

This chapter begins with the skeleton letterforms. Learning these will teach you the basic proportions of the Roman majuscules and of the minuscules which are used with them. The Romans did not use minuscules, but it is useful to learn the basic shapes at this stage because they form the basis for the other minuscule letterforms in this chapter. The Romans didn't use the letters U, J and W so in some alphabets these have been invented for modern usage.

It is not necessary to follow the exact order of the other letterforms given here, but avoid jumping from round letters to ones with sharper angles and back again as this may confuse you and can affect the quality of your letterforms.

> ❝ *The excellence and beauty of Formal Penmanship is achieved chiefly by three things – SHARPNESS, UNITY & FREEDOM.* ❞
>
> EDWARD JOHNSTON

Ladders
The height of each style of letterform is set at specific number of nib widths. Therefore the nib you use acts as a measuring unit to find the height of the letters. The nib widths are made with a pen angle of 90° and are piled up in a formation known as a ladder. You must make a new ladder each time you use a different size of nib or change lettering style. In this way, whichever size nib you use, your letters will always be in the correct proportions. For example, Foundational majuscules (**A**) are 6 nib widths high and the minuscules are 4½ nib widths. Italic majuscules (**B**) use 7 nib widths and the Italic minuscules are 5.

Guidelines
Guidelines are lines which act as a guide for the proportions of the letterforms. These proportions are found by making a ladder and then ruling pencil lines from it. They can either be fine pencil lines ruled on the writing sheet itself or templates placed under the writing sheet so that the lines show through.

Pen angles
The pen angle is the angle between the flat edge of the nib and the horizontal writing line. This varies depending on which letterform you are writing.

90° for ladders

30° for Foundational hand

45° for Italic

Skeleton Roman

These basic letterforms are designed to acquaint you with proportion and a general understanding of Roman-based pen lettering. You need to draw out the majuscules and make yourself familiar with the several groups that they fall into. Unlike the other alphabets, skeleton letterforms do not rely on the "thick and thin" effect of the broad-edged pen so they can be made with any implement. The shape of the letters you draw will improve if you keep in mind that they are all based on combinations of the straight line and the circle.

Specification
The majuscule letters, ascenders and descenders are almost double the minuscule x-height. Numerals are formed slightly higher or lower than the x-height.

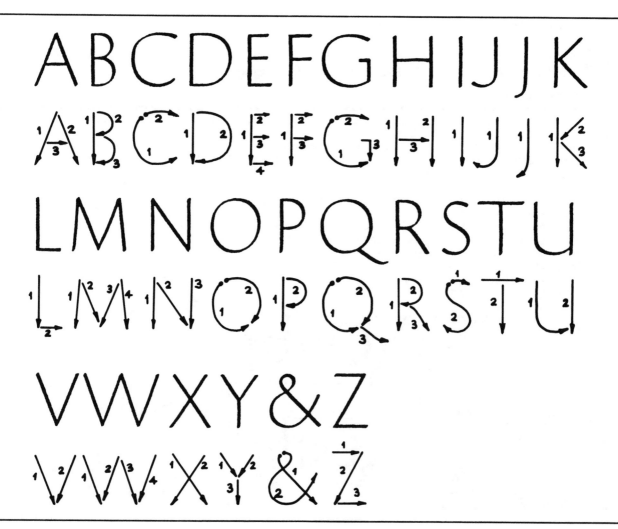

C D G O Q

A H N T U
V X Y Z

M W

B E F J K L P
R S

Forming the letters

These letters are not easy so give yourself time to practice them and don't expect good results instantly! They divide into the four groups (shown *left*). Remember the W extends beyond the basic square; the S should not look bottom heavy, but turning it upside down will prove it actually is. If you misplace the midpoint of R P K B E F G H X Y your letters will look either top or bottom heavy.

You can use any monoline pen or a soft pencil. The sentence "the quick brown fox jumps over the lazy dog" not only uses every letter but also tests spacing problems.

Task
Capitals

Using a soft pencil draw out these capital letters, paying attention to the proportions. Repeat without looking at the examples. Redo letters which are wrong.

Task
Minuscules

Using a soft pencil draw out minuscule skeleton letters, observing closely the proportions. Close the book and go through them again. Correct any mistakes.

abcdefghijklmnop

abcdefghijklmnop

qrstuvwxyz

qrstuvwxyz

1234567890

1234567890

©DIAGRAM

Classical Roman

Roman capitals such as these have inspired lettercutters, typographers and signwriters for well over 2000 years. They were originally drawn with a brush before being cut with a chisel and mallet. They aimed to convey the power of the Roman Empire. In the illustration (*right*) of part of Trajan's Column in Rome, you can see that the letters on the top lines have been cut larger than the ones on the lower lines. This was so that to a person on the ground looking up at the huge memorial all the letters would look the same size. This subtle device matches the elegance and splendor of the letters themselves. Each letter is approximately 3ft 3in (100cm high). Even today official forms command us to write in BLOCK CAPITALS. This serves two purposes. Lettering is more legible than writing and capitals reflect the formality of the business. When you begin to draw Roman Classical letters use a carpenter's pencil, a broad edged nib or a flat brush. Despite their apparent uniformity, the letters have many thick and thin variations and their serifs or finishing strokes require agile pen-work.

SENATVSPC
IMPCAESARI
TRAIANOAV
MAXIMOTRIE
ADDECLARANI
MONSETLOCVSTA

ABCDEFG
OPQRSTU

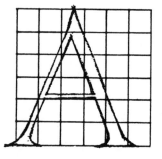
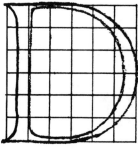
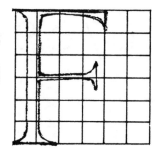
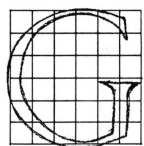

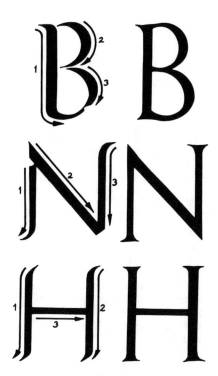

Forming the letters

Roman capitals are written with a broad edged pen held at 30° to the writing line. This angle varies, for diagonals steepen it to 45°. Flatten it for the middle stroke of Z. The serifs and finishing strokes need manipulation of the pen. In order to imitate the chiselled serif the pen serif is completed with the corner of the nib. This technique will only be perfected by practicing it.

Task
Roman capitals stroke by stroke
When you feel ready, start to work your way through the alphabet, making two copies of each letter. Use the stroke order diagram and make each letter 7 nib widths high. Date these sheets when you have finished. Remember to steepen stroke angles on diagonals.

Task
Proportions
Squared (graph) paper can help if you are having trouble with the proportions. Squared paper can be bought in pads from stationers and the paper is suitable for pencil or pen work.

HIJKLMN
VWXY&Z

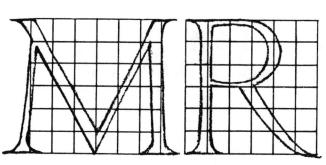
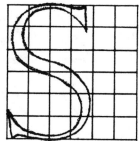
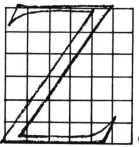

©DIAGRAM

Foundational

This is the hand that calligraphy reformer Edward Johnston (1872–1944) developed at the start of this century for students of calligraphy to begin their studies. Johnston was inspired by a 10th century manuscript, the Ramsay Psalter, to create a lively, springy minuscule which is used with Roman-based majuscules. The latter stem from Roman Capitals.

The pen angle varies a little to achieve a harmonious result. For example, on the diagonals the pen angle is steepened to avoid a weak, thin stroke. The structure of the letters should be analysed and understood before progressing to other hands.

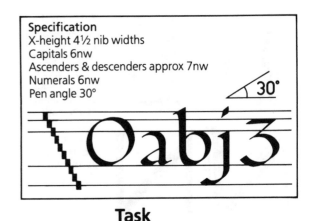

Specification
X-height 4½ nib widths
Capitals 6nw
Ascenders & descenders approx 7nw
Numerals 6nw
Pen angle 30°

Task
Serifs
The triangular serif (**A**) is particularly elegant, while the slab serif (**B**) gives added power to a letter and is used on capitals only. So now work your way through the alphabet and give serifs to your letters.

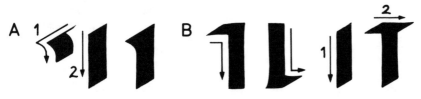

ABCDEFGHIJKL

MNOPQRSTUV

WXYZ & PARIS

Forming the letters

Your capitals should be free and the strokes can end freely with a hairline that complements the minuscule letters. Do not weaken right angles on E L D H K N P R T when creating the serif or a horizontal stroke. Top serifs should not be too heavy either.

The minuscules sit on the line and there should be a continual repetition of the round shape whether it's o c d b g p or q. The letters do not lean forward at all, but tend to sit closely together and are quite free of swoops and swirls found in other hands. Avoid hooking the top of the f, the tail of the g y and the j. The diagonal strokes need a pen angle of 45° to prevent a weak thin line. The tail of the l and t should be generous and stabilize the letter. Don't allow the arches of h n u m and n to get too narrow or have pointed awkward corners. They are based on a segment of a circle and should therefore be quite wide and open. Leave a space only large enough for a minuscule o in between your words.

Task
Learning the stroke order
Take a large, broad nibbed pen and a large sheet of layout paper. Slowly work through both alphabets writing each letter several times to familiarize yourself and memorize the stroke order.

Task
Spacing
Work through the alphabet, using each letter as an initial , writing a short word for each letter. Try to stick to a single theme, such as towns, people's names, animal names, etc. Write once in majuscules and then again in minuscules.

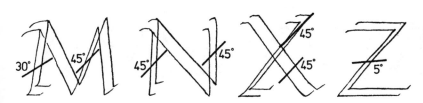

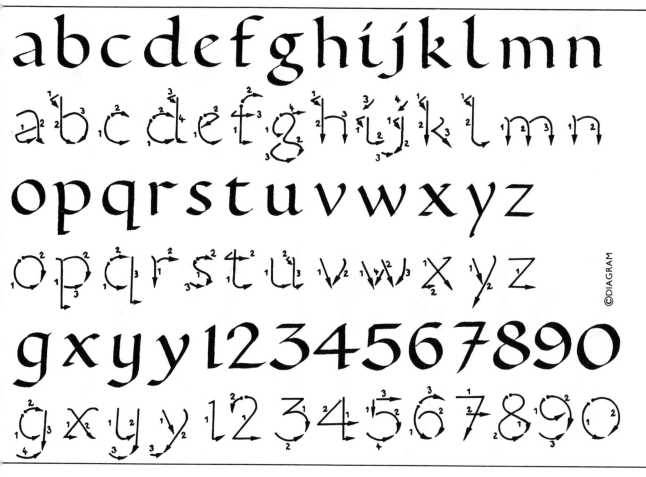

©DIAGRAM

35

Rustica

Not all Roman lettering was carved in stone. This script bears little resemblance to the fine majuscules chiselled by craftsmen into stone and marble. As its name suggests, this is a comparatively informal hand, but it has been used greatly over the centuries for headings and titles.

Rustica letterforms look deceptively easy, but the pen angle varies so much that developing a rhythm is difficult. It has a strong diagonal stress and is very compact. The forms are condensed and interlinear space is minimal.

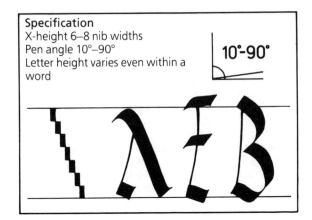

Specification
X-height 6–8 nib widths
Pen angle 10°–90°
Letter height varies even within a word

10°–90°

OCVLLSQVEMALIGISERV

ABCDEFGH

PQRSTVV

Forming the letters

Rustica is best learned with large letters, so you can clearly see the counters (spaces within letters). Use a large nib to contrast the thick and thin strokes. Rustica breaks all the rules for writing in other hands. There is a lot of freedom, based on the need to write fast. Without rushing, experiment with a traditional reed pen or a nylon pen. Writing on textured paper with improvised pens will give you a "rustic" or antiquated image.

A translation between lines of Rustica, called a "gloss," gives a useful explanation to the reader. Letter heights can vary quite a lot, keep your writing compact and springy with minimum interlinear spacing.

This example is taken from an election notice found on the walls of Pompeii (destroyed AD 79).

Task

Rustica and Foundational

Take a simple Latin phrase (a dictionary of quotations might be a good source) and write it with Rustica letterforms. Add a translation in very small Foundational capitals between each line.

Task

With music

Try working while listening to some music. Experiment with pen angles and get the feel of the diagonal stress which varies so much. Find some Latin and write out words and names just for fun.

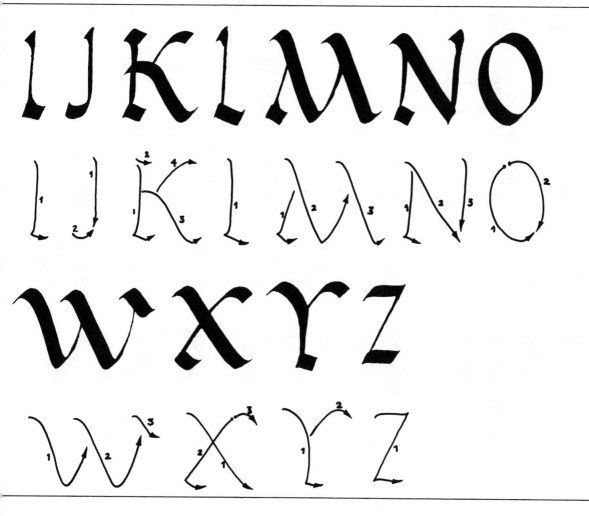

©DIAGRAM

Antique Uncials

Uncial letters (so-called in the 18th century from the Latin uncia) emerged in the 2nd century AD at the same time as parchment and vellum, both of which have smoother skin surfaces than papyrus. Skins could be bound together into a codex (book) and overall the look of the written word changed radically. Uncial became popular with the expanding Christian Church as more dignified and beautiful than the simplified cursive Roman capitals. From the 4th to 8th centuries the Uncial hand virtually replaced Rustica for Christian books and in the copying of pagan literature. The chunky serif is a feature that distinguishes traditional Antique Uncial from its successors.

Specification
X-height 3½ nib widths
Ascenders and descenders 5nw
Pen angle 0°–5°
J K W and Y complete the alphabet for modern usage
No diagonal stress

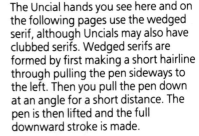

Serifs
The Uncial hands you see here and on the following pages use the wedged serif, although Uncials may also have clubbed serifs. Wedged serifs are formed by first making a short hairline through pulling the pen sideways to the left. Then you pull the pen down at an angle for a short distance. The pen is then lifted and the full downward stroke is made.

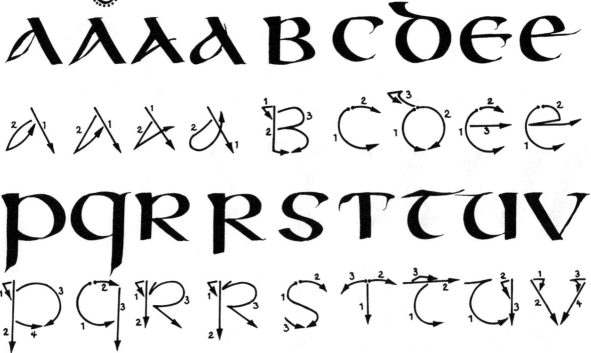

Forming the letters

The pen angle for Uncials is flat, so you will find it useful to keep your elbow tucked into your side in order to maintain the correct angle as you progress along a line of writing. The predominant shape is the flattened O which is found in M H W and T as well as the obviously round letters.

Task
Large names

Use a very large pen and write some friends' names in large Uncial letters. Use diluted fountain pen ink, or gentle color for some names and bright colors for others. Add their birthday dates in very small letters within the design. Keep for future reference.

Task
Music and Poetry

The rhythm of music makes an ideal accompaniment to this very rhythmic hand. Music can allow you to distance yourself from your surroundings – quite appropriate with Uncials and Half-Uncials. Irish poetry might also provide interesting and fitting texts.

Task
Circular writing

Draw two concentric circles, one with a diameter of 6in (15cm) and the other with a diameter of 5½in (13cm). Write in the area between the circles. Choose a short quotation and turn the paper round often, so that you are always writing directly in front of your body.

An example of Antique Uncials from a psalter written in England in the 8th century. The interlinear words (gloss) were added later in Anglo-Saxon minuscule hand.

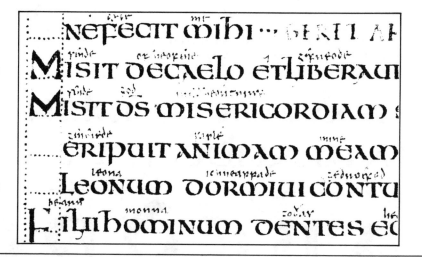

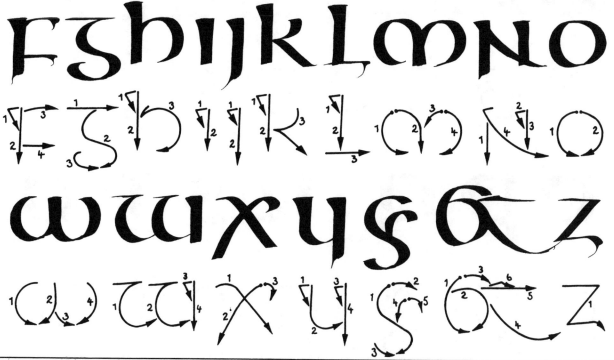

Modern Uncials

The modern form is a derivation from the traditional Uncials. The modern scribe is keeping the spirit of the letter with its chunky serifs and flattened round counters. All antiquated letterforms such as A F G H M are abandoned and the modern versions are used. The pen angle is slightly steepened to facilitate faster writing, and this means that vertical strokes are a little lighter and serifs have a diagonal rather than horizontal top line. You will find this new pen angle easier than the flattened one for Antique Uncials. Finishing strokes taper away to the left.

If you want to write a piece with a Celtic image, this hand is appropriate to use. Many advertisers and graphic designers know this very well and make free use of this hand in their work.

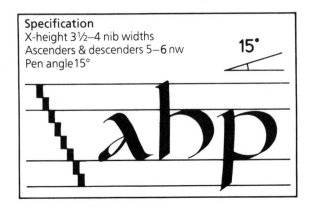

Specification
X-height 3½–4 nib widths
Ascenders & descenders 5–6 nw
Pen angle 15°

15°

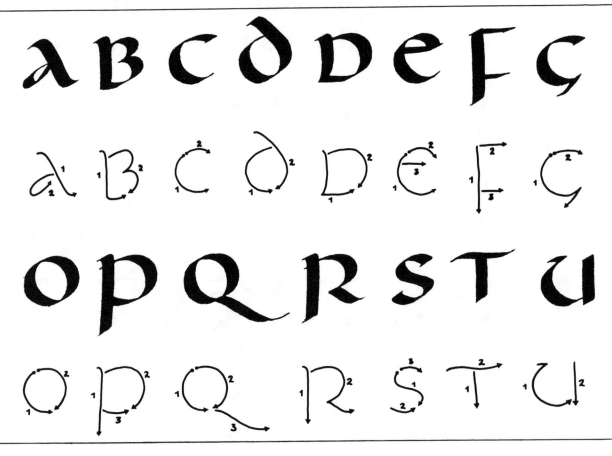

Forming the letters

The pen angle allows you a little more freedom with your arm than you had with Antique Uncials. It is still important to maintain a regular pen angle – this is 15°.

ANTIQUE MODERN

Task
Roundness

Modern Uncials are springy and very rhythmic when well done. Fill a page with writing. Leave only 8 nib widths between writing lines. You should end up with ribbons of writing that when turned upside down look like a free, open pattern. *Never* attempt to squash up the letters. Fill spaces at the end of lines with pen patterns the same weight as your letters.

Task
Double pencils

Use your double pencil and write "the quick brown fox jumps over the lazy dog" so you have used every letter of the alphabet. Compare your version with the letters shown here. The double pencil clearly reveals the structure. Is your angle correct? Do the strokes develop smoothly without creating badly-shaped counters?

Task
The Celtic image

Find a piece of lyrical Irish poetry or prose, so that your text will harmonize with your hand. Work a short piece until it becomes a finished piece, in plenty of space, with or without some appropriate color. Green or red would make the result powerful and vivid. Light blue or gray would add a subtle touch.

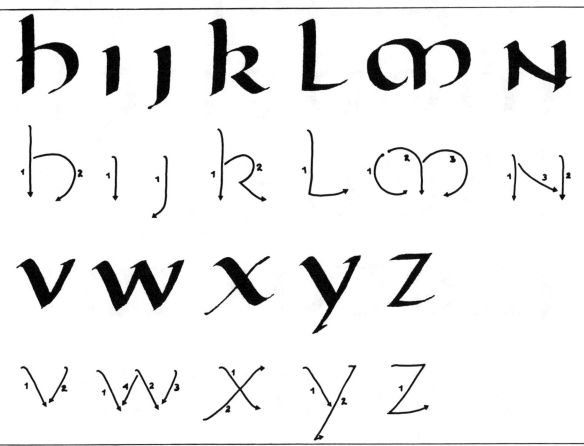

Antique Half-Uncials

Half-Uncials are NOT the minuscules for Uncials. They developed slightly later than Uncials to answer the needs of busy scribes who wanted to write beautifully but more speedily. The letters have a sense of roundness, a heavy wedged serif and are written with the pen angle flattened.

Half-Uncials in the Insular style carry a connotation of Celtic culture. The famous Book of Kells, which is kept at Trinity College, Dublin, was written AD c800 in Insular Half-Uncials, as were a number of other famous manuscripts of that period. The term Insular refers to the islands of Britain and Ireland during the Dark Ages. Half-Uncials anticipate the development of minuscules.

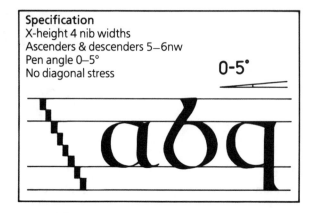

Specification
X-height 4 nib widths
Ascenders & descenders 5–6nw
Pen angle 0–5°
No diagonal stress

0-5°

Forming the letters

Keep the Celtic image, the roundness and the chunky serifs. The new letterforms allow the scribe to keep the pen stroke flowing, rather than build up a letter with four or five separate strokes. The g shows this most clearly. You can use these letters for headings also and, if you wish, paint in the round counters to give the heading more emphasis. Add tiny black dots around the colored counters for a Celtic effect.

The ascenders and descenders are short and headings need very little interlinear space, thereby adding more weight and greater contrast compared with the text. Serifs are formed as in Antique Uncials.

A detail from an 8th century Irish Insular manuscript.

Task
Think "round"
Practice the letterforms, concentrating on the roundness of them. Use diluted ink and write Latin, or use names, so that word patterns can develop.

Task
Line fillers
Half-Uncials look very chunky, so design complementary line fillers. Use the monsters from old manuscripts for inspiration. Use rows of dotted lines around the beginnings of names and color in the counters (spaces within letters) with paint.

©DIAGRAM

Modern Half-Uncials

Antique Half-Uncials, although quicker than Uncials, are still quite slow to write. They serve the patient scribe copying old manuscripts, but are unsuitable for the needs of calligraphy today. Twentieth century calligraphers, by turning the pen to a 15° angle and modifying some of the letter-forms, produced a hand known as Modern Half-Uncials. The very round letters, with their short ascenders and descenders, can be written quickly and rhythmically, but retain much of the original Celtic image. For this reason they are often asked for by graphic designers and typographers.

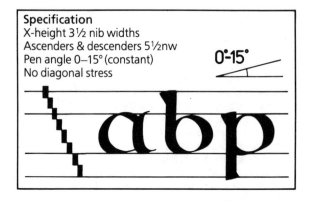

Specification
X-height 3½ nib widths
Ascenders & descenders 5½nw
Pen angle 0–15° (constant)
No diagonal stress

0°-15°

donegal·galway·armagh·sligo

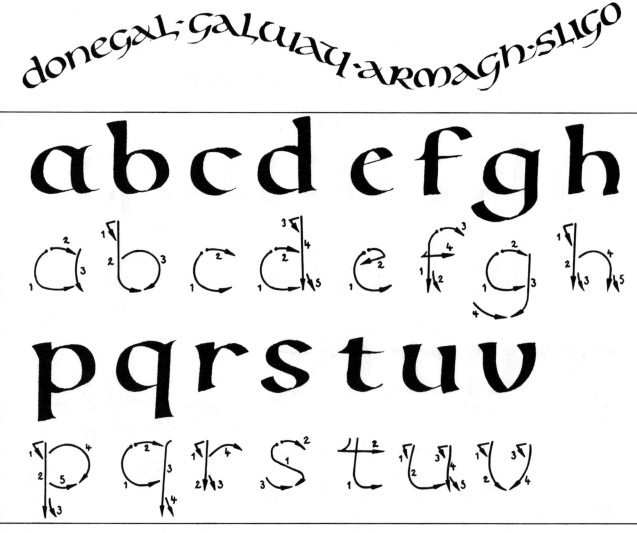

Forming the letters

In the examples (*right*) we can clearly see the difference between the Antique (**1**) and the Modern (**2**) Half-Uncial hands. The antiquated letterforms are absent in the modern hand which looks much more like the lowercase alphabet we know today. Concentrate on the roundness.

¹Ihterrogabat

²bokklubben

Task
Shapes

Uncials form ribbons, so consider writing in two columns or around a circle and on wavy lines (these are drawn with a flexi-curve). One quotation could be written in a variety of shapes, all of which are appropriate to Uncial letters.

Task
Texts

You can break with tradition on occasion and use Uncials merely because the lyrical quality of the letters suits your text. Poems, prayers, and philosophical prose can all work well with Modern Uncials. Look widely for possible texts.

Task
Compare details

Write "the quick brown fox jumps over the lazy dog" in Uncial and Half-Uncial using both modern letterforms and the antiquated letters. Look at all four versions and see the subtle differences. Date these examples and store for future criticism and comment.

irish linen

©DIAGRAM

45

Carolingian

The Carolingian hand was named after Charlemagne (reigned 768–814), an emperor who never learned to write! However, he understood the power of the written word and commissioned Alcuin of York and his scribes to rewrite many manuscripts. The distinctive book-hand which they created was the forerunner of the letters you see here.

Carolingian was the first genuine minuscule. It has no majuscule form. Usually combined with Roman, Versals or Uncials, it was the most commonly used hand until Gothic took over during the 12th century. It has one letterform with which you may not be familiar – it resembles an elongated r and was adopted because it has fewer strokes than the usual s. Observe the very long ascenders and descenders. They require the lines of the Carolingian hand to be well spaced.

Specification
X-height 3 nib widths
Ascenders & descenders 8nw
Pen angle 30°
Club serif

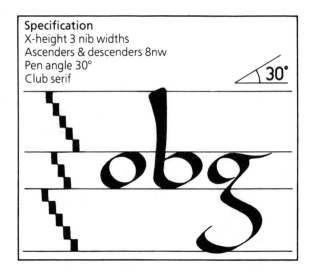

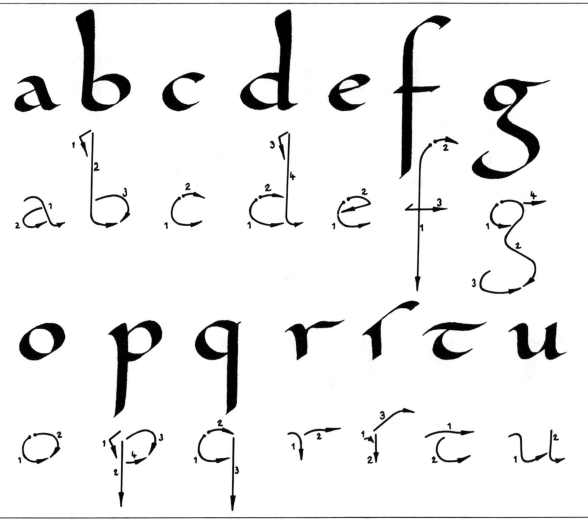

Forming the letters

The Carolingian hand needs plenty of interlinear space as the ascender, with its heavy serif, needs height, and the descender balances it below the writing line. The serif is the device to concentrate on. The two strokes need to blend accurately into one mark; this will come with practice. After learning the antiquated s form, it can be abandoned if you consider the regular s to be more appropriate. The 30° writing angle and very round counters are important characteristics of the hand.

Serifs

The characteristic clubbed serif of Carolingian is formed in a similar way to that of the Uncial hands. Make a hooked downward stroke first (**1**); the long upright stroke (**2**) butts up to it.

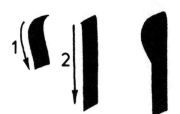

Task
Elegance

Find a text which you feel Carolingian elegance would be ideal for. Work it into a finished piece and make it a gift to an elegant person. Try using handmade paper, if possible, and use shades of blue. If you need capitals use Foundational majuscules.

Task
Samples

Write out "the quick brown fox jumps over the lazy dog" several times. Concentrate on long elegant ascenders.

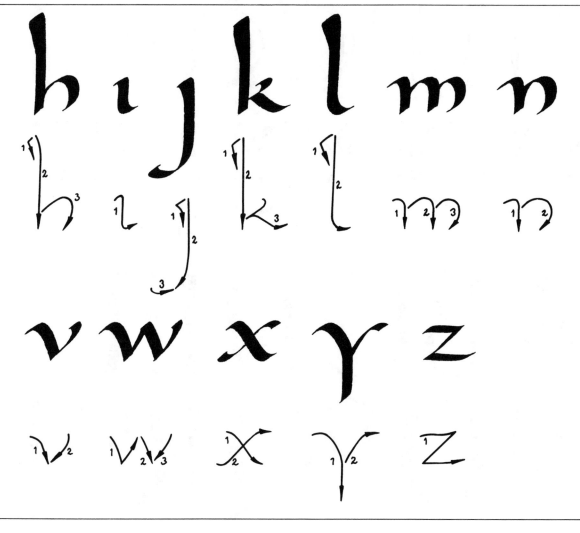

Versals

These elegant capitals are used for headings and to begin verses, hence their name. They combine well with Carolingian Foundational, Italic and Uncial. Traditionally, Versals were outlined with red paint using a fine pen and the gap filled with the same paint using a fine sable brush.

Where a series of Versals was needed down a page, a sequence of red/blue/red/green was usually adopted. Versals were often gilded.

Forming the letters
Versals are built-up letters and are drawn, not written. Draw the inner stroke first to establish the shape of the counter, then add the outer stroke. With vertical strokes aim for the subtlest of shapes, slightly waisting the stroke in the middle. Don't exaggerate this feature. Hairlines should be lightly drawn with the pen held 90° to the writing line. Dilute your paint as it gradually dries out and gets too thick for penwork.

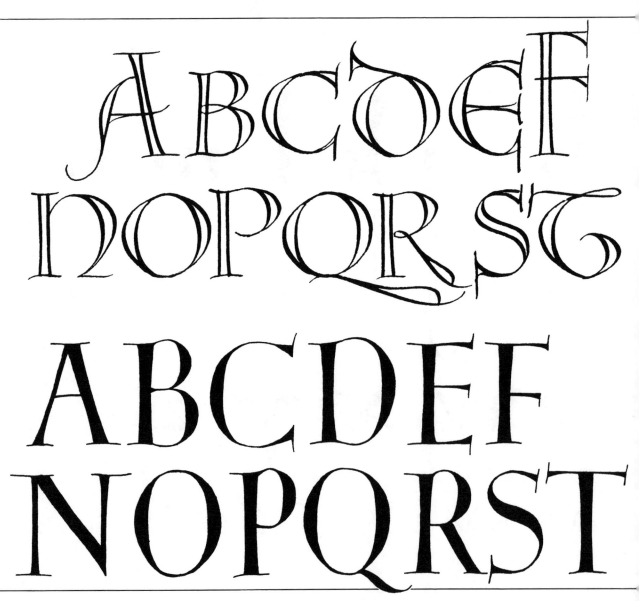

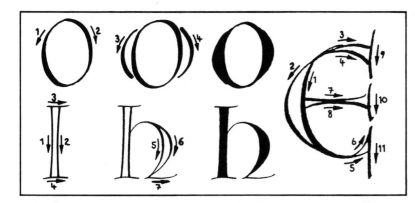

Task
Practice Versals

Using red paint mixed to a milky consistency and a fine nib, draw the outlines of these letter shapes. Turn the pen for the hairlines and the thin strokes. After five or six letters, flood the letters with the paint using a fine sable brush. Check your proportions and stroke widths.

GHIJKRLM
UVWXY3

GHIJKLM
UVWXYZ

Lombardic Versals

These extravagant letterforms are produced in the same way as the Versals on the previous page. They were first created in medieval northern Italy as their name implies. They can be a superb design feature, but need to be used sparingly as they tend to overpower a text.

Three types of versals
1 Lombardic letters by the American typographer Frederic W. Goudy (1865–1947) published in 1918.
2 Spanish 16th century Versals with elegant waisted strokes and exaggerated hairlines.
3 Dutch Decorated Versals by Evert van Dijk with diamond shape pattern and embellished hairlines.

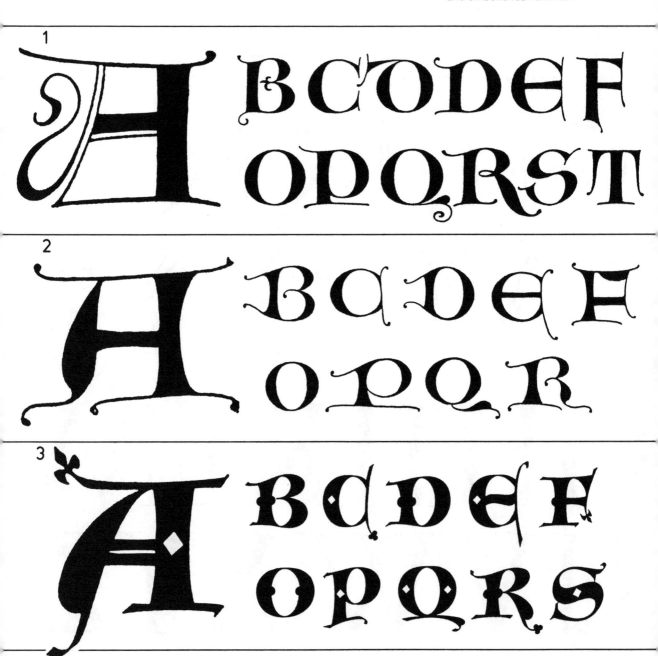

Task
Family names
Develop some family names with Lombardic Versals, using color appropriately. Keep the very round quality of the individual letters and add patterns and devices to the large colored areas. Aim for an heraldic image.

Task
Huge
Use Lombardic letters at least 2in (50mm) high so there is plenty of room for a detailed pattern within the strokes. Work in black and white on one short word or name. Trace or photocopy the result many times and make a repeat pattern of your design.

Task
Miniature illustration
Use Lombardic initials as frames for tiny detailed paintings in the counters. Obviously O D C H N P and Q are ideal. Your initial could be ¾in (20mm) or 1¼in (30mm) high. Gain inspiration from old examples. Watercolors and sable brushes are best for this illumination work.

GHIJKLMN

TUVWXYZZ

GHIJKLMN

STUWXYZ

GHIJKLMN

TUVWZ

51

Basic Gothic

There was a powerful economic reason for the introduction of Gothic letters. Increased production of books had led to a shortage of vellum and parchment and therefore an increase in its cost. Calligraphers had to get more writing on each page! For this reason Gothic has little space between lines, the letters are tightly packed and the penforms are angular – even the o has corners. For further compactness ascenders and descenders are short and letters are compressed, sometimes to the point of sharing a common stem. Abbreviations are widely used.

It is the compactness on the page which gives Gothic writing its nickname Black Letter. The density of a page of Gothic is enlivened by the use of vermilion majuscules, whose roundness contrasts with the angularity of the minuscules. However, both majuscules and minuscules are difficult to read unless they are carefully spaced.

Technique
Turn your wide pen 90° to the writing to make Gothic serifs and capitals.

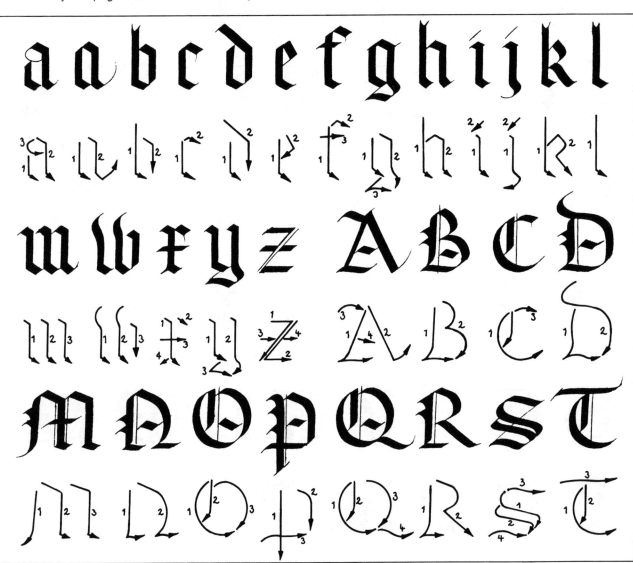

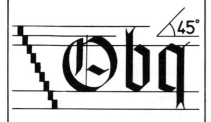

Specification
X-height 5 nib widths
Capitals 6nw
Ascenders & descenders 7nw
Pen angle 45° (90° for hairlines)

Task
Practice spacing minuscules
The basic stroke is the letter i. Aim to balance white space with black mark. Check your work by turning it upside down. Words should resemble a set of railings (*see below*).

Task
Building up majuscules
Use a double stroke automatic pen or another large nib. Practice majuscules until you are familiar with them.

minimum

m n o q p r ſ s s t u v

Traditional Gothic variations

There are a lot of Gothic variations. Beware trying to write one that was originally a typeface! You need a variation that was originally a pen form, in order to study and emulate it. The basic requirement is legibility, so beware the ornate versions such as the Textura on this page when writing a long text. There are only a few opportunities to use Gothic calligraphy. When they occur give yourself some time to revise your knowledge of the letterforms. The time will also build up a confidence that will give you the regular rhythm that Gothic requires.

With Textura the "basic" stroke is, in fact, 3 individual strokes and this will mean you write slowly and lift the pen more often than with other Gothic hands.

ABCDEFGHIJ

KLMNOPQRS

TUVWXYZ

abcdefghijklmno

pqrstuvwxyz

1234567890

Textura Gothic

A Textura Quadrata script written in France in the early 14th century. The letters have a rhythm which prevents the page looking heavy and dull. The fine hairlines are achieved by turning the nib onto a corner and using little or no pressure on the pen (*below left*).

Dürer's Gothic

Gothic capitals designed by Albrecht Dürer in the early 16th century are not easy to learn, but very lively. They contrast with his traditional Textura Gothic minuscules which tend to be very formal and regular (*below*).

Task
Rhythm

The strong rhythm of Gothic means that this hand is ideal if you have had a long break from calligraphy and need to practice. There is a strong vertical stroke which will encourage you to hold the pen at a consistent angle.

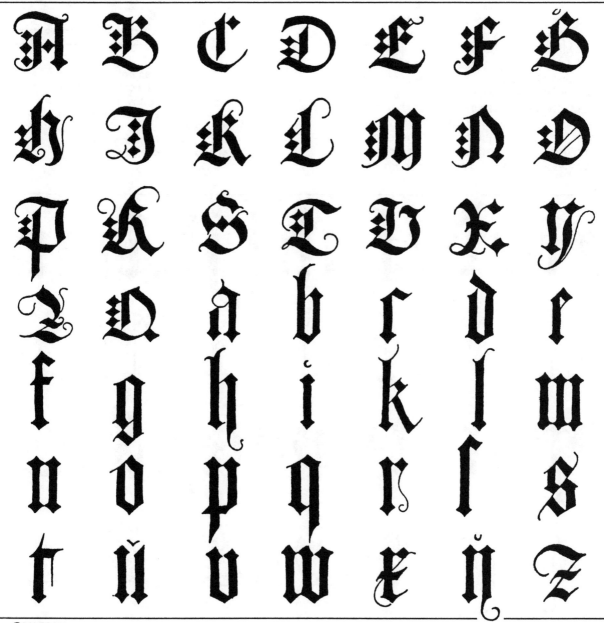

Modern Gothic variations

There are two variations of Gothic which mix Gothic characteristics with Italic influences. The difference between them can clearly be seen here. With the modern condensed hand there is an air of formality. It is suitable for writing prayers, instructions and rules, and conveys dignity and authority without being archaic. Foundational capitals work very well with it and their roundness balances the angular minuscules in the traditional way.

With the pointed Italic you can see Gothic arches are mixed with the Italic proportions and rhythmic flow. The result is an informal lively hand, crisp and sharply defined. It is ideal for light prose, greetings and witty texts. It also works very well on an undulating writing line drawn with a flexi-curve. The long ascenders and flaring descenders demand more interlinear space than is usual for Gothic. It looks effective written in color, but should be avoided when writing a book or narrative, as it lacks the regularity and steadiness needed for a long text. Use Italic capitals, either simple or with swashes, with these thoroughly modern letters.

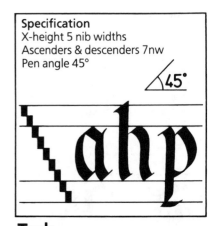

Specification
X-height 5 nib widths
Ascenders & descenders 7nw
Pen angle 45°

Task
Condensed only
Write out a prayer using this hand. Compare it with a traditional Gothic version. Develop the version you prefer into a finished piece of writing. Exhibit for criticism and comment.

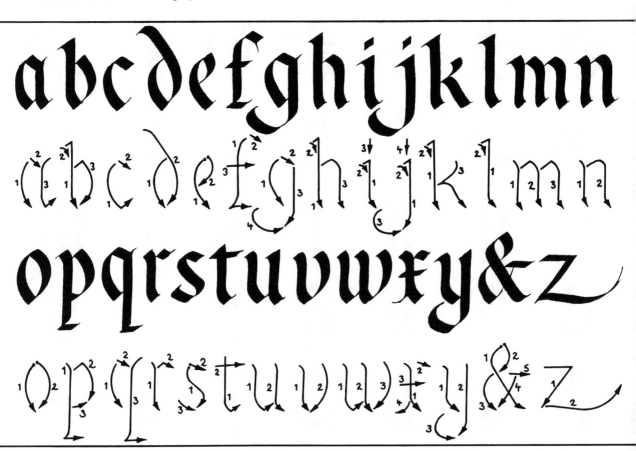

Task
Initialled greetings cards
Using textured card or paper make a simple greetings card. Write initials in red on the outside of the card and put your message on the inside. A set of cards with large initials on the outside and blank inserts could provide you with your own distinctive stationery.

Task
Pointed Italic only
Find a witty text and, using a flexi-curve, draw gently undulating lines instead of traditional straight ones. Develop this into a finished piece using color. Avoid a rainbow effect, work in tones of one color. Date and exhibit for criticism.

Modern Gothic
pointed italic

abcdefghijklmn

opqrstuvwxyz&

©DIAGRAM

Rotunda Gothic

Southern Europe suffered the same economic pressures that led to the introduction of Gothic in Northern Europe. However, Italian and Spanish scribes rejected the rigid angularity of its letterforms. They therefore produced a hand which, while a true Gothic, is also a compromise with earlier letterforms. The rounded letters got the hand its name – Rotunda. It is robust and round, but retains a compactness with its short ascenders and descenders, and needs little interlinear space. It works well with musical notation.

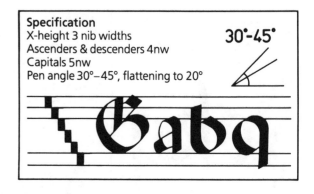

Specification
X-height 3 nib widths
Ascenders & descenders 4nw
Capitals 5nw
Pen angle 30°–45°, flattening to 20°

30°-45°

rundgotisch

abcdefghijklmno

pqrſstuvwxyʒß

&ꝛꝏ!?1234567890

Forming the letters

Be prepared to adjust your pen angle. The serif is made with two strokes, and the pen is flattened to complete the serif and at various other times (*see below*) forms a flattened top to the ascender. Flatten the pen angle for the serif, for dots, full stops (periods), and crossbars. Turn the pen for the thin lines on the capitals.

Task
Round and sharp
Rotunda combines Roman roundness with Gothic sharpness. You need to practice the shapes and the spacing, so write *words*. Retain the roundness in the counters and sharp corners at stroke junctions. Don't extend ascenders and descenders. Date your practice sheets.

Task
Capitals
The roundness in the capitals is similar to others, so some letterforms will seem much like other Gothic variations. Some letters, however, are strange and

Task
Minuscules
Take a short text, prose or poetry, and use it to practice with. Start writing with a steel nib and then an automatic pen. Don't forget to vary the size of the letters, but not the number of nib widths. When you feel confident, make a final version of your text with letters only ¼in (6mm) high. Date this and store for reference.

need more time spent on them. Study this alphabet with your double pencil pen, then a large steel nib and finally an automatic or a Coit pen. Date and store practice sheets.

Formal Italic

While Germany developed the tight and economic Gothic script, it was Italy which created the most elegant of letterforms – Italic. This again is a generic term for a family of hands all of which have the same characteristics but which also have many variations. What they all have in common is the branching arches and the elliptical o shape.

As you continue your study of Italic letters you will find a considerable number of variations. It is a letterform that lends itself to decoration and embellishment. To begin with, though, look at Italic in one of its simpler forms. When ruling up allow plenty of space for long ascenders and descenders and avoid being angular as you write. The 5° lean to the right will develop as you learn to write with speed and rhythm. Do not aim for speed at the beginning, it will tend to distort your letters!

This flexible letterform will serve you well and you may find yourself using it more than any other for your project work.

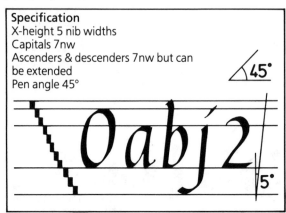

Specification
X-height 5 nib widths
Capitals 7nw
Ascenders & descenders 7nw but can be extended
Pen angle 45°

Forming your letters
A constant angle and parallel strokes are essential. Italic letters without ligatures (joining strokes) are more formal. Ligatures tend to speed up the writing, which in turn creates a more informal look. This is known as cursive. Avoid using all variations or the serif in one piece of work!

Task
Letter Construction
Using the double pencil, write out the alphabet, both majuscules and minuscules, so that the construction of the strokes and serifs is understood. Use large sheets of layout paper. Date these early attempts.

Task
Double pencils
Using double pencils, write out "the quick brown fox jumps over the lazy dog". Check for bad habits such as sloppy strokes, weak joins, squashed counters and bunched-up words. Turn your work upside down for criticism and rewrite the sentence. Date the second version and store safely.

Sample
Here we see the regular rhythm of formal Italic at its best in a French manuscript of 1550. It was written in Rome by Victor Brodeau for the French Ambassador to the Apostolic. See (right).

Pour charite, vne occulte vengence,
Pour humble port, vne estreme arrogance.

ABCDEFGHIJKL

MNOPQRSTUVW

XYZ 1234567890

Italic with swashes

Swashes are decorative extensions of the letterstrokes. While they add nothing to the meaning of the writing they can, nevertheless, imbue the text with a feeling of grace and elegance. They are often used for display work, for greetings and on stationery.

On the minuscules swashes are extra long ascenders, curved tops or long flaming descenders. Swashes serve as introductions to the majuscules and in a text are used as headings or initials. Hairlines often extend the line of the swash. To work well, a swash needs to be a confident line. This comes with practice, as does knowing when and where it is appropriate to use swashes. The danger lies in doing too much to your text with the result that the words become too cluttered and the reader is distracted.

1

ABCDEFGHIJKLM

2

ABCDEFG OPQRST

3

abcdefghijklmnopq

4

abbcdefghijklmnop

Italic variations

1 Elegant majuscule alphabet in basic Italic with added swashes.
2 More ornate capitals.
3 Minuscule alphabet which can be used with **1** or **2**. It has hooked ascenders and generous hairlines.
4 Minuscule alphabet with x-height extended to 6 nib widths which makes a light elegant hand ideal.

Task
Small letterforms

Use a fine nib (W. Mitchell No. 4 is ideal) or quill to write names and practice swashes on majuscules. Then practice minuscules by writing lines of names. Develop a name into a design by extending the capital letter and then experimenting with ascenders and descenders available.

Task
Large letterforms

Use a Coit pen, an automatic pen or a large felt tip to write these swashes as large as possible. Use 11 × 14in (A3) size paper and work freely. Look at the counters and the shapes of swashes when assessing your attempts.

NOPQRSTUVWXYZ

HIJKLMN

UVWXYZ

rstuvwxyzß&&ſt

pqqqrstuvwxyyyy!?

©DIAGRAM

63

Roundhand or "Copperplate" 1

Copperplate is a general term for a family of Roundhand writing styles which developed from Italic in the 16th century. This new style was flowing and looped and the pen was not lifted from the paper. Variations of this basic Roundhand, which was introduced by Gianfrancesco Cresci of Milan in 1560, soon spread throughout Europe except Germany which retained the Gothic image. The new style suited the new printing method of engraving onto a copperplate. Pictures and writing reproduced well and Roundhand writing became known as "Copperplate".

It is used today whenever a formal look is needed.

The traditional tool is a fine flexible pen. This was originally the quill. Since the invention of the steel pen in the 1830s there are two sorts of nib, broad edged and fine pointed. For Copperplate writing you need a flexible pointed nib and the technique is to apply controlled pressure on the *downward* strokes. Finishing touches are permissible. Much practice is needed, not only to acquaint yourself with the ornate letterforms, but also to gain experience of the pressure technique with the flexible pointed nib. Look at the next page before you start work on this alphabet.

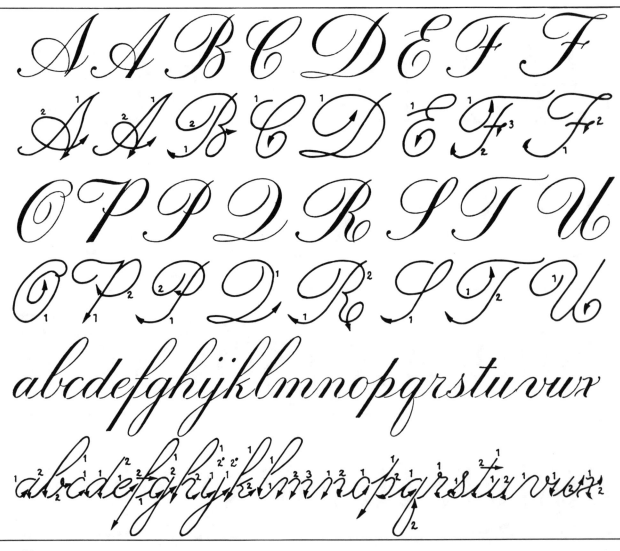

Specification
X-height about 7 thick strokes of the nib
Ascenders & descenders 3 x-heights when looped, less when straight
Capitals at least 3 x-heights
Numerals 10–11nw
Pen held at 55° to the horizontal
These dimensions are only a guide to Copperplate and variations are permissible, but in all cases the steep pen angle of 55° is constant. Apply pressure to open the nib when measuring the x-height. Ink reservoirs are inappropriate as they restrict flexibility.

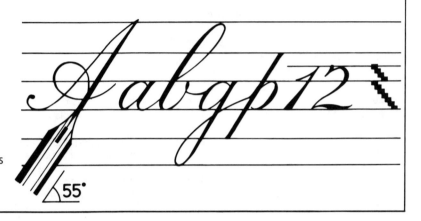

G H I J K L M N

G H I J K L M N

V V W X Y Z

V V W X Y Z

yz. 1234567890.

yz 1234567890

©DIAGRAM

Roundhand or "Copperplate" 2

On this page is another Roundhand alphabet. This
elongated version is extremely fine and shows
some letterforms to work on. Observe
the lack of looped ascenders in this minuscule hand
which looks deceptively simpler than loops, but
in practice this is not the case!

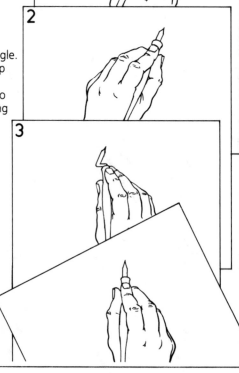

Strokes
There are four strokes for
Copperplate.
1 Part of the letter is formed with
hairlines as the nib travels across the
paper.
2 When pressure is applied the nib
widens and forms swells that begin
and end in hairlines.
3 Some strokes have square ends.
4 Hairlines joining letters are known
as ligatures.

Hand, pen and paper positions
1 Right handed 55° Copperplate
angle.
2 Left handed 55° Copperplate angle.
3 Elbow joint pen designed to help
right handers.
4 Adjusting the paper position also
helps you write at 55° to the writing
line.

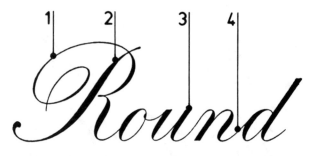

Round

A B C D E F G

P Q R S T U

a b c d e f g h y k l m n

Forming your stroke

Practice the basic strokes. Learn to mark lightly then apply pressure on the down stroke and release it by the time you reach the writing line. Curves and loops are created *without* pressure, while the down strokes are thick from creating considerable pressure. The nib opens a little with the additional pressure allowing the ink to flow freely and make a wider mark. Reduced pressure gradually closes the nib and so narrows the ink flow. For the final curve of the stroke a light touch is needed, to narrow the nib back to a fine point.

Practice strokes

These five patterns below will help you to establish your pressure and release technique with the flexible-pointed nib. Do each exercise over and over again until you can keep all of the strokes consistent. Music can help you acquire regular pattern marks.

Task
Technique

Experiment with the pressure technique by creating repeat patterns out of several of the letters, lo bi pr qu wo, etc. Too much pressure will damage your nibs, which should then be thrown away.

Task
Minuscules

Old writing manuals had pages and pages of text to copy, so that school children would learn to write well. Select a text and keep writing, only using minuscules. Don't cross through bad letters, simply rewrite the word and fill the page with your writing.

Task
Capitals

After mastering minuscules, write a text with capitals beginning each word. Capitals on their own are impossible to read, rather like Gothic capitals. They work with minuscules. Take a few capitals at a time and learn their construction.

Review

Throughout this chapter you've seen numerous letterforms and followed a great number of instructions. Before you can write well and capture the spirit of the letter you need to see letterforms in context within words and written in lines. Here you see several examples by historical writing masters that should help you to assess the overall image of the letters. It is when you see whole pages, complete with headings, margins, illustrations and glosses that you begin to appreciate the subtleties of the letters and their cultural message. It is essential to see letters in finished manuscripts, to see the color, examine the texture and appreciate the sheer beauty of pen-made letters.

Historic manuscripts
1 Roman Rustica capitals from the *Codex Palatinus* in the Vatican Library, Rome, 4th to 6th centuries.
2 Uncials from an Anglo-Saxon written *Rule of St Benedict*, 7th or 8th century.
3 Insular Half-Uncials from the *Lindisfarne Gospels* written in NE England c698.
4 English Carolingian minuscules from the *Benedictional of Aethelwold* (Bishop of Winchester's blessings), probably written 963–984.

BEATI GREGORII

PAPE URBIS ROMÆ

5 Versals from *The Dialogues of St Gregory*, 12th century French manuscript.
6 Page of Italic from Juan de Yciar's *Arte Subtilissima* (1550 edition published at Saragossa, Spain).
7 Gothic Textura from the English Queen Mary Psalter, 15th century.
8 Rotunda with musical notation from a North Italian Dominican Gradual or choirbook, late 15th century.

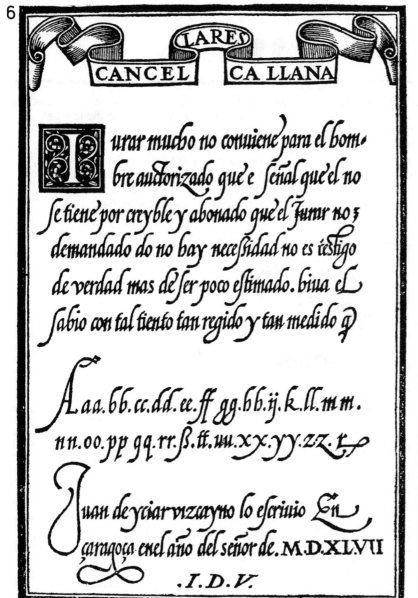

Chapter 3

 The artist needs the letter, the letter needs the artist.
RUDOLF VON LARISCH

It is necessary to learn about the method of ruling up and transferring down guidelines accurately before applying your knowledge of penmanship to finished pieces. There are several methods, some of which have been used by scribes for centuries.

Some are more complicated than others and all have advantages and disadvantages. Nevertheless, they allow the calligrapher to be accurate and

make more efficient use of time, which in the end results in better work. Merely using the familiar ruler and a pencil will lead to inaccuracies. Equipment that makes lines square or parallel is well worth using. Soft pencil marks can easily be rubbed out if mistakes are made, but a hard pencil is best for lines which will never be erased. These should be hardly visible to the reader.

Pricking through

Careful examination of old manuscripts reveals this time-honored method. It saved the scribes time and ensured that all pages of a book matched. When you have successfully completed one piece of work, you can use it as a "master" by pricking through with a pin or other sharp point where each line starts and finishes. The prick marks will show on the pages underneath and can then be joined up in light pencil using a rule. The tiny holes can be hidden afterwards by rubbing gently on the back of the paper with a fingernail.

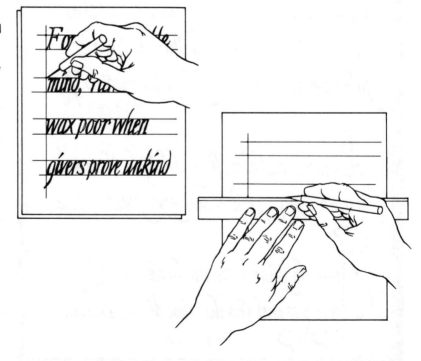

DESIGN AND DECORATION

This chapter is concerned with the preparation, handling and presentation of your written pieces. These are neither secondary nor ancillary techniques nor casual afterthoughts, but an essential part of the routine for planning and setting out your calligraphy to the best possible effect. They can both save valuable time and also do much more to enhance the appearance of your finished lettering.

Transferring lines

A paper rule is used for transferring measurements from an original in order to make accurate copies. You can make a paper rule from a piece of card. Hold it against the original margin and mark off the positions of the writing lines using a very sharp hard (4H) pencil. The rule is then placed against your fresh sheet and the marks transferred using your pencil. An alternate method is to use dividers to transfer measurements from the original to the copy (see illustration page 25). Remember to keep a record of the nib sizes and colors used in your work for future use.

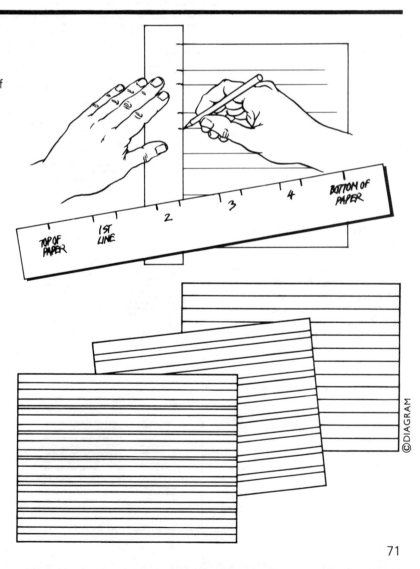

Pre-ruled sheets

These are sets of ruled lines that are placed underneath your layout paper and which will show through, indicating where you should write. Having several available, each one drawn to the correct size for the nibs you use most, will be very useful. You can also make up page layouts with marks indicating margins and spaces for large initials, headings, etc. Photocopied enlargements and reductions can be made.

©DIAGRAM

Layout

Your job as a calligrapher is to produce a good page or broadsheet. For this you need to know the traditional layouts that have served well over the centuries.

Margins are essential to present your writing and these must not be undervalued. If in doubt leave plenty of space and trim gradually!

Planning a text is essential at the beginning of a project. It is not an afterthought. Write out your words and then see which layout would present them best. Don't be too rigid, a left-hand margin is only *one* of many starting points. You have a lot of decision making to do. Your resource box is invaluable here.

Calligraphers, like actors, are interpreters of someone else's words so read through anything before you write it out so that you can pick out the subtleties, humor, pathos energy or any other human emotion which may lie within it and develop them. Remember, whatever is being expressed, it must be done so LEGIBLY. Your main objective is to render clearly your understanding of the author's words.

Historically, calligraphy competed with illustration and words became overwhelmed by artists whose pictures could be understood by non-readers. Don't be tempted to add too much decoration and embellishment to your page. Let the calligraphy breathe.

Alignment

There are five basic ways of aligning text:

A Justified; both the right and the left hand edges form a straight line.
B Ranged (flush) left; the left hand side forms a straight line.
C Ranged (flush) right; the right hand side forms a straight line.
D Centered; the lines are uneven in length – but the layout is symmetrical.
E Asymmetric; the lines are not aligned and are freely positioned.

Using columns

Traditionally, Bibles and religious texts have been written and printed in columns. This is an ideal way of putting a lot of writing on one page. If you are writing a book consider the effect of both pages being sewn together. Historically, if one page had a lot of illumination or headings, the other would be simple.

1 Versals used to introduce paragraphs.
2 The *verso* (left-hand) page is simple. The *recto* (right-hand) page is illuminated.
3 The right-hand column is the main text and the left-hand column is a translation which is in a different color and often using a finer pen. Translations are traditionally known as glosses.
4 The left-hand margin is staggered so that it complements the right-hand side.

Margins

Space around work is essential. Customarily in a book the margins are in the ratios 2:3:4:1½. With a broadsheet you must use your judgment. L-shaped pieces of card are the easiest way of helping you make this decision.

Task

Spacing

Write out a menu and photocopy it several times. Experiment with the layout, centering and offsetting it. Vary the space between courses and paste up several versions. Stick them all on the wall and eliminate them one by one until the "best" version remains. Write out again.

Interesting layouts

Refer to historical manuscripts and various cultural sources when considering layouts. Below, some of the many variations:

1 Use space to focus attention onto the letters. This device is frequently used in Eastern art.

2 If you have a large text, try splitting it into two columns. Bibles and some secular manuscripts were often done this way.

3 Embellish the opening of your text with large words. This was often done in Bibles and manuscript books.

4 Stagger the work quite freely. This would be appropriate for a humorous quotation or a lyrical rhyme.

5 and **6** Use geometric shapes to give structure and add to the image.

Paste-up

A paste-up is a version of the design in which the separate elements of the design are assembled on a background sheet and stuck down in their correct positions. With these in front of you, it's easier to choose which layout to use for the finished piece.

©DIAGRAM

73

Illumination and color

We associate old manuscripts with gold and an abundance of color to enhance the writing. Traditionally, this was done by a rubricator who added red initials to the page and artists who filled counters with small pictures; the gilder applied the gold before the artists drew their designs. Nowadays you have to do all these jobs!

The basic rule to follow always when mixing paint is to add the water to the paint, *never* the other way round. This applies whether you are using cakes, tubes or jars of paint. Keeping colors such as vermillion and white in screw-top jars will encourage you to use them more. Diluting some black fountain pen inks will give a gentle grey-blue tint which is very subtle and effective. To avoid accidents when using colors, make sure your brush handles are short so that they do not knock over jars of paint. Securing bottles of ink and color to the desk also helps.

When using color on a long piece of work you may have to keep adding water to the paint to make up for moisture lost through evaporation. If this occurs, add just a few drops of distilled water using a dropper. Try not to do this too often or the color will fade toward the end of the piece of work.

Finally, always try to keep the paint consistency milky – thick paint can look very unattractive and is difficult to handle.

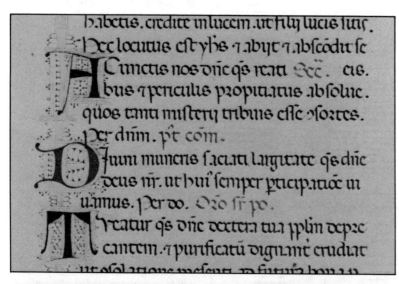

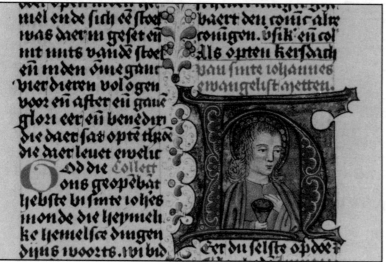

Illumination
Traditionally the manuscript was written before the decoration. Beware trying to perfect a piece of writing. The picture, the initial, the gold and the other colors are there to enhance the page not to compete with the text. When many people could not read, these pictures conveyed a lot of the meaning of the words and played a big part in communicating the Bible stories to the laity.

If you are no artist you can team up with an artistic colleague. Alternatively, simply keep to natural forms, or refer to old manuscripts or designer reference books. Traditional patterns are drawn with a fine nib and larger areas are flooded in using a fine sable brush.

Late Gothic ornamentation
These two manuscripts each have good examples of traditional illumination. The top one, a Latin missal from Milan (c1390–1400), has large Lombardic Versals in color to begin each paragraph, surrounded by simple line decoration. By contrast, the Dutch breviary from Utrecht (c1490) is highly ornamented (*left*), the large initial is filled with a painting, and decoration is based on natural plant forms surrounding the columns of text.

Sources of initials
Books of decorated initials are a great source when you are trying to design one for yourself. There is no need to try and be original; adapt what you find and retain the balance of weight between the design and your page of writing.

Task
Red and black
Using red and black on white paper write a piece using Gothic letterforms, red for the capitals and black for the minuscules. Consider using a translation here.

Task
Hot and cold colors
Draw some Versals and use the Foundational color scheme of red, blue, red, green. It can be a greeting or a quotation. Balance the hot and cold colors in your project.

Red letter days
When a medieval scribe wrote out a text he would leave spaces for the capital letters. The text would then be passed to the rubricator who painted in the red initial letters. When calendars were written out, the saints' days were usually written in red. Special occasions thus became known as "red letter days".

Task
Children's rhymes
Take a nursery rhyme and, using color to give charm and freshness, write it out. (Try not to make it look like a rainbow!) Pen drawings can also be used to decorate this if you wish. Try using either Carolingian, Foundational or Half-Uncials. Date and store for reference.

today is your red-letter day

© DIAGRAM

Gilding

Gold leaf, when applied to a slightly raised surface, catches the light. In a manuscript, this is known as illumination. The term now embraces the practice of painting pictures and patterns within and around initial letters.

An illuminated letter is usually in the Versal hand, and the cushioned surface which the gold adheres to is made from gesso, which is a mixture of chalk, fish glue and other ingredients. Gold leaf, once stuck to the gesso, is burnished until bright. The effect can be stunning! Using gold in the traditional way is not easy without practice, so two simpler methods are also illustrated here.

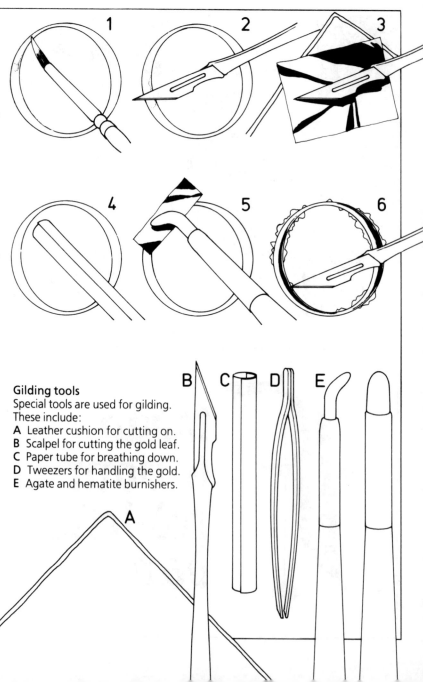

The traditional method of gilding
This process can be fraught with difficulties, but if you have ever seen an illuminated manuscript you may find the desire to try it for yourself too strong to resist!

1 Using a fine nib, draw out the shape of the Versal letter to be gilded. Move your work to a flat area and flood in the gaps within the strokes using a fine sable brush loaded with gesso. Work quickly and allow the gesso plenty of time to dry. It helps if a little color is added as milky gesso is not easily seen on the page.

2 Using a sharp knife, gently scrape the domed surface of the gesso "cushion". Aim to flatten its general shape and to remove tiny holes left by air bubbles.

3 Gently take a piece of gold leaf from its protective booklet by sliding it onto a leather cushion. Cut it into pieces about the size of a postage stamp. Take great care not to disturb the gold leaf with jerky movements, or it will float away!

4 Make a small paper tube (about the size of a cigarette). Breathe deeply down this tube onto the surface of the gesso. The purpose of this breathing is to dampen the surface of the gesso for the gold to stick to it.

5 Apply the piece of gold to the gesso with a pair of tweezers and a silk cloth to press it down. Then use an agate or hematite burnisher to rub the gold firmly, particularly around the edges.

6 Burnish the gold until it shines brilliantly. Remove excess gold from around the outside of the letter using a brush if it is loose, or the point of a sharp knife if it is sticking firmly.

Gilding tools
Special tools are used for gilding. These include:
A Leather cushion for cutting on.
B Scalpel for cutting the gold leaf.
C Paper tube for breathing down.
D Tweezers for handling the gold.
E Agate and hematite burnishers.

Transfer gold

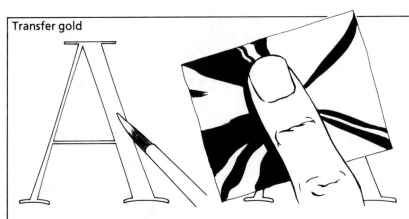

1 Use PVA (polymer emulsion) not gesso. This can be bought from art shops. Dilute with a few drops of water, and tint with a tiny amount of gouache before use. Draw out the letter and flood in the wide areas with a fine sable brush. Allow the PVA to dry for at least 30 minutes.

2 Breathe heavily on the PVA to make it tacky. Lay the sheet of transfer gold on the letter. Press down firmly on the back of the sheet, especially around corners and edges.

3 The gold is burnished indirectly, through a piece of clean transfer paper from the booklet of gold leaf. Rub the burnisher over the letter until the gold begins to shine.

Shell gold

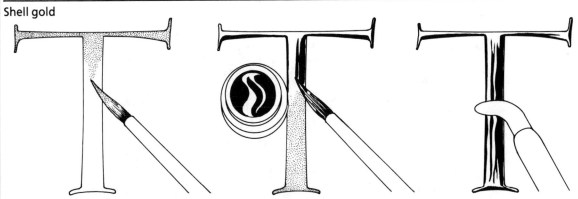

Shell gold is available from specialist art shops. It is a form of gold paint which can be burnished.
1 Draw the outline of the letter with a fine nib in the usual way. Using a fine sable brush, fill in the spaces with an undercoat of colored paint (yellow ochre gouache is the most suitable). Allow plenty of drying time.

2 Stir the shell gold well before use and apply to the undercoat with a fine brush, covering the undercoat completely.

3 When dry, burnish gently to begin with and gradually apply more pressure, either through a piece of crystal parchment or directly onto the gold. Shell gold can be decorated in the traditional manner by making marks on its surface using a sharp instrument.

© DIAGRAM

Task
Transfer gold
Practice gilding using an offcut of vellum, PVA and transfer gold. Make notes on the details (amounts used, drying times, etc) so that you can benefit from these experiences.

Task
Shell gold
Experiment with shell gold on dark paper to create a dramatic impact. This can work very well with a text. The writing can be in white using white poster paint kept at a running consistency.

Task
Gift
Make a gift to a special friend by gilding his name or a short quotation on an offcut of vellum. If you decide to frame gilded work, always use a window mount so that the protective sheet of glass is held away from the raised surface of the gold.

Review

These techniques are second nature to a graphic designer or a lettering artist. To a novice they may seem complicated and even unnecessary, but they have stood the test of time and work well. Trying to do a piece of calligraphy without thorough planning, ruling up accurately and designing the layout in detail is foolish. The writing needs to be the final touch to your project. Preparation for that is essential, so that you can write freely without worrying about line length, ascenders, descenders "hitting or missing", etc. Traditional techniques with gold and color are still used today.

Even though we live at a hectic pace, these practices cannot be rushed. Expertise can only come with constant practice. Nevertheless, working with this book should have proved to you that practice can be fun, that working at alphabets is fascinating and that experimenting is just another word for "playing".

Here are some examples of modern calligraphy where the scribes are using traditional tools and methods, and achieving a high standard of work, without it looking dated.

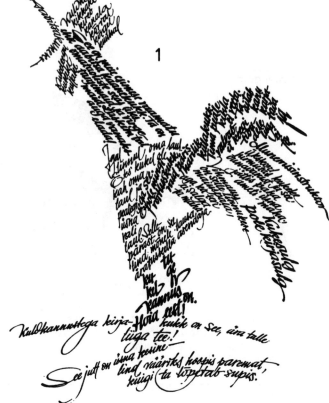

1

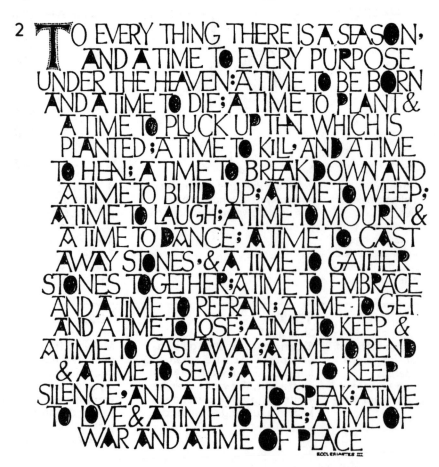

2

3

1 Old Estonian sayings written with a quill by Villu Toots 1970.
2 Ecclesiastes III from the Bible, by Ian Mattingley. In the original the counters are in gold.
3 Poster for a calligraphy course by Peter Thornton 1985.
4 A teaching exemplar to show students variations in letter weight, by Peter Thornton.
5 A humorous North American comment, by Anne Trudgill 1988.

4

I SHALL
BECOME BUT A
SPARKLE
OF LIGHT
AND FILL YOU
AND YOUR
LITTLE LIFE
WILL BE A
LAUGHING ORB

I SHALL
BECOME BUT A
SPARKLE
OF LIGHT
AND FILL YOU
AND YOUR
LITTLE LIFE
WILL BE A
LAUGHING ORB

I SHALL
BECOME BUT A
SPARKLE
OF LIGHT
AND FILL YOU
AND YOUR
LITTLE LIFE
WILL BE A
LAUGHING ORB

I SHALL
BECOME BUT A
SPARKLE
OF LIGHT
AND FILL YOU
AND YOUR
LITTLE LIFE
WILL BE A
LAUGHING ORB

5 It's hard to soar with eagles

When you work with turkeys

Further reading

US publishers in brackets

Backhouse, Janet
The Illuminated Manuscript
 Phaidon, 1979

Camp, Ann
Pen Lettering
 Adam and Charles Black, 1984 (Taplinger)

Child, Heather
Calligraphy Today
 Studio Vista, 1976 (Taplinger)

Jackson, Donald
The Story of Writing
 The Parker Pen Company, 1981 (Taplinger)

Johnston, Edward
Writing & Illuminating, & Lettering
 Adam and Charles Black, 1987 (Taplinger, 1977)

Knight, Stan
Historical Scripts
 Adam and Charles Black, 1984 (Taplinger, 1986)

Lawther, Gail and Christopher
Learn Lettering and Calligraphy Step-by-Step
 Macdonald, 1986 (North Light, 1987)

Stribley, Miriam
The Calligraphy Source Book
 Macdonald, 1986 (Running Press, 1986)

International Calligraphy Today
 (Watson-Guptill, 1982)

Modern Scribes and Lettering Artists
 Studio Vista, 1980 (Taplinger, 1984)

The Book of Kells
 Thames and Hudson, 1980 (pb) (Bantam, 1985)